D0369354

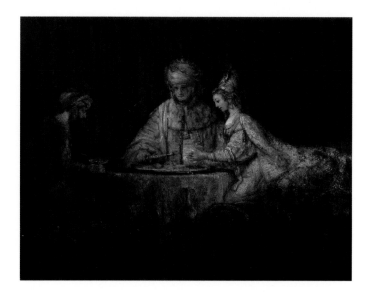

Look Again

How to Experience the Old Masters

with over 100 illustrations

Ossian Ward

 Thames & Hudson

On p. 1 Peter Paul Rubens, *Tiger, Lion and Leopard Hunt*, 1615–17. Musée des Beaux Arts, Rennes (detail; see full work on p. 79)

On p. 2 Rembrandt van Rijn, *Ahasuerus and Haman at the Feast of Esther*, 1660. Pushkin Museum of Fine Arts, Moscow

Introduction
A New Way of Seeing the Old

The art of the distant past can seem very far away. Rather than a portal to another time and place, it often remains a flat picture, standing in for history, mystery, storytelling, doctrine or idolatry. It might feel a long way off, despite being right in front of you. This kind of art usually hangs from silk-covered walls or in hallowed museum halls, preserved in frames or behind protective glass. For all the intervention of such soothing lighting and reverent settings, much of our cultural heritage may as well be buried under centuries of rubble, so hard can it be to penetrate through to the actual image, to the artist's original thoughts and desires.

The term 'Old Master' is in many ways a vague construct shrouded in myth and misapprehension, but for my purposes covers art made anywhere and any time before the 20th century (although many artists of the 1840s to the 1890s might be better described as among the nascent 'New Masters'). The notion of mastery further removes us from these painters and sculptors, implying some kind of higher power and even a superiority that us mere mortals cannot approach or ever hope to understand. This book and its simple methodology will attempt to strip away if not time, then at least some of the distance between us and them.

The art of the past might be passing us by for other reasons. There is evidence that contemporary art is increasingly the bigger draw for viewers through its accessibility and availability, as well as because of society's insatiable neophiliac quest for the newest, hottest and most glamorous of everything. Museums are under pressure to sell tickets and attract new audiences, of course, but this is not to say that blockbuster exhibitions of Old Masters are not still pulling in huge numbers or indeed that visitors to permanent collections are dwindling significantly – at least not yet. But more can be done to introduce the attractions of older art to a younger crowd, so that the traditional or classic might still seem innovative and fresh, so that the stories, scandals and epiphanies in these works can sing out once more.

One of the problems, perhaps, is that Old Masters by their very definition seem to be artworks out of time. They are stuck in an immemorial past, only existing as unattainable, unknowable objects created by demigods of unimpeachable genius. Their place in the chronological flow of art history allows us to broadly position these pieces and their makers into easily definable categories such as the Renaissance or the Baroque, although there are less familiar styles and epochs in between and after (Mannerism, Rococo, Symbolism, to name but a few). But these, too, are general terms used to describe whole centuries of art and vast swathes of human endeavour. Such vague notions of what these movements are meant to signify can further blur our understanding of Old Master pictures, many of which have already been rendered unclear by the chasm in time between the moment of their making and now.

The history of art is a noble attempt to tether these masterpieces, these objects of marvellous beauty or deep thought, to one continuous, linear narrative – starting from the most primitive daubs through to the heights of pictorial achievement. But this itself presents a great barrier, a wall of text or knotty theory, and a seemingly insurmountable bank of prior knowledge. Of course, the history of art is also there to shine a light on the political, social and personal attitudes of the time, most of which tend to be forgotten or unknown nowadays, but just as often it is yet another layer of complexity and information keeping the picture's secrets from us. This is not to say that we cannot learn from these texts, it is simply that we must first train ourselves to read the paintings in front of our noses, before we refer to the wall labels or the exhibition catalogues.

It may seem paradoxical to be reading a book suggesting that the best way to close the gap between a contemporary person and an Old Master painting might not be through this, or any other book. However, in many ways what you are reading is a complementary volume to my previous book, *Ways of Looking*, in which I first stated that the understanding of art needs to initially take place in the beholder, before it can be transmitted onto paper or imbibed through words. Over 40 years ago, John Berger's famous *Ways of Seeing* (1972) began with his assertion that a baby learns to see before it learns to talk, read or compute things in the world. A child reacts to its surroundings with electrons and neurons firing off in the brain to form new connections and knowledge centres. This act of visual perception inevitably leads to thoughts and verbal

reactions, much in the same way that art stimulates first the eye, then the brain and finally, perhaps, the pen. In other words, we should learn to look before we try to read. Yet as adults we are so governed by experience and afflicted with a general over-saturation of mediatized stimuli – we are rarely surprised or shocked by anything nowadays – that we struggle to view the world with that innocent, childlike gaze any more, preferring guarded, sceptical and dismissive glances to long, penetrating looks.

Instead of replaying similar laments to Berger's – about our inability to spend time looking around us in this age of digital duress and the unstoppable speed of data flowing around us – it is better to focus on the particular skills required in the act of sizing up an Old Master painting. Certainly part of the challenge with contemporary art is working out what exactly constitutes a work of art in the first place – is it above, below, in front or all around? – whereas with an Old Master painting, that game is null and void, as it is usually all there within the framed image in front of you. This provides structure and boundaries, whether within a canvas border, atop a plinth, nestled in a display case or perched high above a civic plaza.

We know instinctively where to begin when looking at a painting, a sculpture, a decorative object or a statue. Without the urge to constantly switch attention from one thing to the next, in order to figure out which free-form elements combine with each other to create a work of contemporary art, the impetus when faced with an Old Master painting is to scan the entire picture plane, to notice different passages of paint and pick out details. In comparison with the angular, angst-ridden ride of contemporary art, the comfortable armchair of an Old Master allows you to wallow in its nooks and crannies and settle down, without fear of missing out on the bigger picture.

Yet there is still some residual fear associated with traditional art, just as there is mistrust and bafflement in the face of the most recent of works. That moment of cultural panic when faced with an object or image for the first time in a museum can be just as strong when that work is a composition of tumbling angels or a portrait of an unrecognizable gent from a bygone age, as it might be for the unmade bed or the line of bricks. Indeed, those readers who are well versed in contemporary art may find themselves at a loss when it comes to historical art.

Even for those who know some of the works in this book, however, familiarity can breed contempt, because while we know that we should

Look Again

appreciate a Vermeer, a Turner or a Leonardo – surely included among the Old Masters for good reason – we are not always sure exactly why. This is not solely art history's fault, for giving us our de facto heroes laid out along a clear continuum and in hierarchical order. It can also be the audience's fault, for trusting in the timeworn name brands and tried-and-tested tropes, as well as through our ever-handy screen-based devices or the museum's audioguides, handouts, wall labels and countless other interpretative aids at our disposal. While they can enhance our knowledge, they can just as soon become crutches that deaden our initial encounters and make us lazy lookers, guilty of relying on everything else but our own wits.

This book and its methods are designed to jettison the fears and fault lines in prior knowledge that block or hamper our experience of art. That word, 'experience', is apt, because this is not just a visual exercise or a test of one's mental ability to recall historical facts, but an admission of the ways in which art can affect our lives, brighten our mood or challenge our previously held beliefs. Many people believe they instinctively know their own taste – 'I know what I like and that's not it' – when in reality they may be thinking, 'I don't have a clue about this period, artist or style', so they don't engage; or, 'I worry that I might miss an obvious reference or the salient points of this work', so, rather than risk embarrassment, they move on to another piece. This is the 'chocolate-box effect', when retreating to an easy or pretty picture becomes the safe option.

Rather than concerning yourself with the possibility of arriving at a wrong-headed response, I want to advocate allowing a physical, immediate reaction to the art you see, before turning inward to process its finer qualities. Lead with the eye and body; the mind will fill in the gaps later. This doesn't mean striking some yogic posture – straight back and chest thrust forwards – but is about being more bodily engaged and looking more actively.

Scaling or measuring your own frame up against the protagonists of the painting can give you a sense of proportion or even involve you in the action. If the figures are life size, they might be beckoning you to join them, or they may be turned away as if to keep you out. The feeling of being able to walk into a painting – despite the leap in time and space required – is sometimes a vindication of the artist's intention to interact with the viewer.

Of course, the notion that you can be alone with a great Old Master and devote your undying attention to it is frequently and frustratingly impossible: there might be a crowd around the work; you might be being shunted unceremoniously around a timed, ticketed blockbuster exhibition with only 30 seconds to peer over someone's head or past the selfie-taking tourist. Again, this is part of the modern experience of looking at art (however unfortunate) and can require a particular state of mind to allow yourself to rise above the din and the jostle in order to see clearly.

Preparing oneself for the enquiring or penetrating look is not simply a matter of standing stock-still in front of a painting either, as some huge canvases require a certain amount of to-ing and fro-ing, while smaller works may need to be seen up close and intimate. Looking at art involves a certain dance, perhaps a tentative approach or a healthy distance, some furtive glances or an uncertain period of flirtation – all this before any relationship or rapport can be established. Sometimes it is love at first sight, or else the beholder must seek a more protracted moment to properly experience the beauty or meaning behind the silent interface taking place between subject and object. This exchange or engagement is such that relative positions become fluid, roles reverse and works can reflect our thoughts or even life itself.

All pictures can benefit from a wider perspective – even the context of how and where a work is hung can be important, from its immediate surroundings and the architectural detail, to the building that houses it (you may be stood in a room in a museum, the nave of a church, a palace, the former home of landed gentry, and so on). Maybe the piece was commissioned for the very spot you are in, or perhaps it has been removed from such a place in order to preserve it. This sense of being firmly rooted in a location can give a work its power or resonance, but the context and owner may have changed numerous times. Then again, the specific theme of an exhibition or the juxtaposition of a neighbouring work can just as easily colour, cloud or elucidate a reading of what is in front of you.

Rather than trying to travel back through time and imagine what a viewer made of the picture when it was first painted, this book advocates that we 'look again', using our faculties as a contemporary person with contemporary references. This thing that is a window to another era – a survivor of decades, centuries, even millennia of external events and changing ideas – is also an object in the here and now, and we should treat it as such. What does it say to us and in what language? How might

it be relevant to our lives despite its age? Can this picture hold our attention in the 21st century?

My first book ended, somewhat ironically for one about contemporary art, with a self-portrait by Rembrandt van Rijn, so I would like to begin this one with the same Old Master. *Ahasuerus and Haman at the Feast of Esther* (1660; ill. p. 2) is in the painter's quintessential late style, built up of layers of jewel-like encrusted paint blobs and dark swathes of canvas. No matter that this biblical story taken from the Book of Esther about her husband, probably the Persian king Xerxes I, and his wrath at the discovery of her Jewish faith, is all but obscured by the passage of time, as the painting itself seems to be a product of time passing. It is evidently ravaged by damage and unsatisfactory restorations – its broken surface barely discernible behind a layer of glass – yet this adds to the brooding sense of drama around this table, over which the king stares into space (see detail; p. 12) and we stare back at him through centuries of craquelured paint. Although plainly not a product of our time, Rembrandt's bravura handling means that it feels more modern than its 350-year age would suggest.

This act of translation into the present tense is not an attempt to dumb down or bring Old Masters modishly up to date, but to connect us to them directly, without the weight of history bogging us down. Instead of treating these pictures of the past as though they were preserved behind an impervious layer of amber, we should feel entitled to argue and quarrel with them – to query, interpret, judge or interrogate them. Icons of art or not, nothing is critic-proof and everything is accessible, approachable and, ultimately, should be understandable.

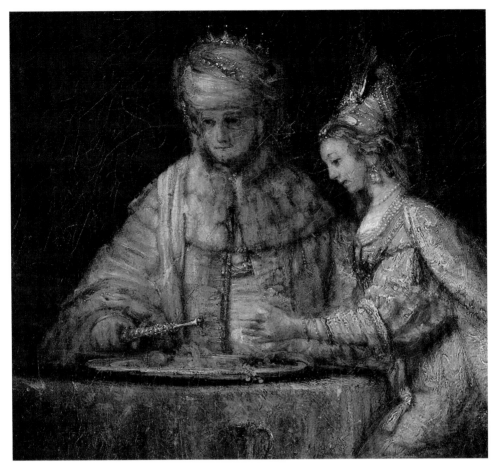

Rembrandt van Rijn, *Ahasuerus and Haman at the Feast of Esther*
(detail; see full work on p. 2)

Look Again

T.A.B.U.L.A.

My methodology, the original 'ways of looking', consists of an easy-to-remember 10-step programme. Most important is to start with a clear mind, with no preconceptions. This is what I call the 'tabula rasa', the blank slate ready and waiting for reinterpretation of the appreciative scrawlings being made by your subconscious. This in turn acts as the simple mnemonic, T.A.B.U.L.A. R.A.S.A., with each letter standing in for a different part of the act of looking.

The first six steps mimic our subconscious processing of images, from reading to assimilation and, finally, evaluation. Once these strategies – Time, Association, Background, Understand, Look Again, Assess – have been absorbed (and they need not be practised in this order, or with all of the steps rigidly adhered to), then the next level – Rhythm, Allegory, Structure and Atmosphere – can be attempted. Each step will be followed by an example from art history, called a 'Spotlight', demonstrating how these techniques of looking might be applied.

T for TIME

There are no guidelines for how long one should spend with any work of art, unless, of course, it was created in a time-based medium (such as performance or video art) or unfolds in a temporal manner (such as a piece of music or literature), all of which tend to have a discernible beginning, middle and end point. Besides, the actual amount of time spent looking is largely immaterial, as one can never fully comprehend an object of the past. It is impossible to discover exactly how an ancient sculpture was made or ascertain which was the first or last brushstroke to touch a canvas. We can never know precisely what the artist was thinking, or how different external factors – from light conditions to the political context – affected his or her hand.

One eminent art historian, T. J. Clark, spent many weeks and months looking at just two paintings every day for his book *The Sight of Death* and, indeed, some paintings have become like old friends that I habitually visit. I often leave a big exhibition in order to seek out one or two special pictures in whichever museum or wherever I happen to be, knowing that I will never exhaust them, no matter how many times I return. A simple

rule of thumb might be the three-breath rule: take a few long inhalations and exhalations in front of each piece. This might sound like some kind of mindfulness ritual, but looking at art can feel akin to meditation. And while this book advocates as long and as slow a process of looking as is possible to muster, it is also about exercising swift and sometimes merciless judgments. Time is precious, so don't spend too long in front of a work that doesn't grab you or pique your interest.

There are many reasons why some artists and images are prized beyond all others, and we will soon tackle many of these – their skill of execution, ability to conjure up atmosphere or to depict the world faithfully – but many awkward, overly busy, saccharine, overbearing and plain dull artworks can be skipped over just as quickly (after all, you can't really see a whole national gallery in one visit). This level of speedy discernment only comes with patience and practice.

Spotlight on Time
The few tufts of white paint scumbled over patches of dark grey immediately call to mind voluminous pillows of cloud, scudding across the sky. These swift works on paper were made by John Constable on Hampstead Heath, London, in bursts of intense outdoor study, which he referred to as 'skying'. While he made a whole batch on various painterly jaunts out of the studio between July and October in 1822, only some of his oil sketches were accurately dated and time-stamped – '10 o'clock morning looking Eastward, a gentle wind to the East,' for example (the version pictured opposite merely has the word 'cirrus' inscribed on the reverse).

Constable's weather reports were so accurate that historians have been able to identify the actual day and hour of contemporary events, and even to post-date some of his own pictures, with his scientific approach in determining exact cloud formations also a mark of his accuracy. Rather than a photographic record, however, this glimpse of sky approximates the feeling of looking up to the heavens (literally, 'skying' your vision) and spotting a bank of clouds on the move. His was a Herculean or Sisyphean exercise that would now be comparable to a durational work of conceptual art, or a prolonged performance in the pursuit of something so fleeting as to be all but ungraspable.

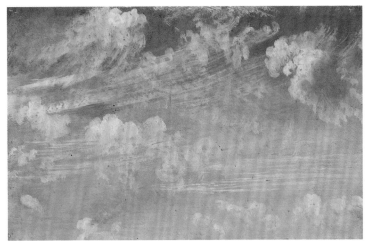

John Constable,
*Study of Cirrus
Clouds*, c. 1822.
Victoria & Albert
Museum, London

On p. 17 Johannes
Vermeer, *Girl Reading
a Letter at an Open
Window*, 1657–59.
Gemäldegalerie Alte
Meister, Dresden

A for ASSOCIATION

An association can be as fickle as the sensation that a particular work of art is worth spending some of the aforementioned time with. Rather than judging it on a whim, use your whole being to make this first link. Forget the content or context of the imagery and go with your instincts here. It might be a pretty or passable picture, but does it speak to you? Is the scene lively and stimulating, or still and poised? Do the characters seem to be addressing you personally, or imparting their emotions or their stories convincingly? It could be a strange detail – a beautifully rendered shadow or a figure's intent gaze at something beyond the frame – which turns your head and stops you in your tracks.

　　Any such visceral, intellectual or visual appreciation of a painting is likely to be rooted in personal preferences and might emerge from a recollection or reflection of your own life, be that in the accurate depiction of a mood, a time of day or the landscape of a place. You might recognize a mother's tender relationship with her son, the depiction of sisterly affection, or a look on someone's face that reminds you of a friend. Certainly, in these instances, Old Masters should be easier to relate to than their modern or contemporary counterparts, being essentially figurative and humanist in orientation. Physical attraction is another means of association – when

confronted with a beautiful face or a lithe figure in action – but you could equally be gripped by squalor, ugliness, conflict, suffering or the plight of others.

It may not take much time at all, often a split second is all that is needed to find that empathy between you and the picture. Not all the emotions and complexities hidden within a work need reveal themselves in this instant, but there is the possibility to sense at least some of the impending drama, intensity, energy, jeopardy, sadness, regret, ridiculousness, calamity, space, time, beauty and subtlety, before an Old Master reveals itself more fully.

Spotlight on Association

A dramatic moment, often repeated in paintings by the Dutch master Johannes Vermeer, zeroes in on a woman clutching a letter, specifically on her face, which is positioned squarely in the centre of the picture (opposite). She reads intently, her elbows stuck firmly to her side and both hands tensed, perhaps awaiting news from a far-flung lover (the open window suggesting her desire to flee from the prison of her home). This is a momentary sensation we can all relate to, when a message threatens to change our lives, turn our stomachs or uplift our spirits – all in the space of just a few words. We seem to be peering in at this most private of moments, from an adjacent room or from behind the plush curtain, but Vermeer is capable of imbuing even the most detached scenes with empathy and universal significance. The surrounding details and intricate reflections all conspire to concentrate our attentions back on to the ochre-coloured figure; even the shadows are tinged with a deeper note of the same hue. Whether she is herself the scandalous subject of this letter, as has been surmised in some art-historical accounts because of the presence of the 'forbidden fruit' in the foreground, we only know that we are on her side, that we, too, feel her pain.

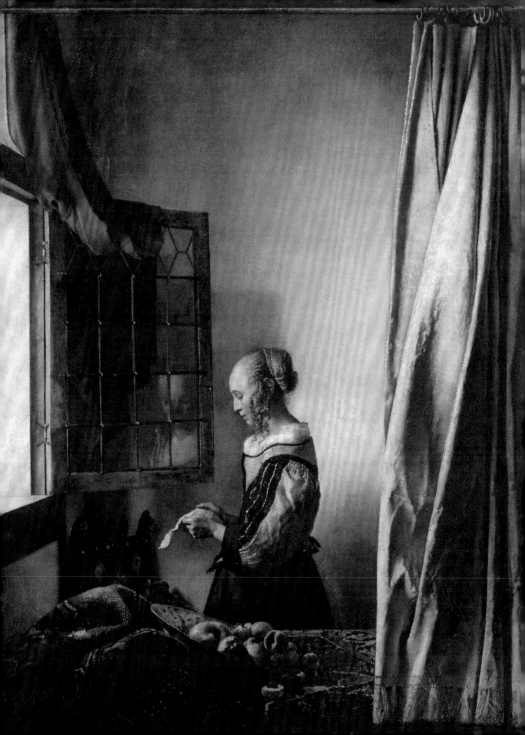

In the realm of Old Masters and art history, we are led to believe that background is king. After all, we don't discuss the Old Amateurs, the mediocre artists of bygone eras, or the anonymous toilers. Yet many of the first truly great artists were themselves nameless, or known subsequently by a general title such as 'master', or perhaps 'follower', or as someone from the studio of a well-known artist. Of course, this was in a time before celebrity, since when the mere mention of a big name focuses the mind like no other marker of taste. Rembrandt, Michelangelo and Titian are all guarantees of quality, demanding our respect and courting admiration – and they generally get it.

But what's in a name? After all, some of these paintings are still being misattributed or reattributed hundreds of years later, thanks to new technologies or research methods, making hitherto trustworthy paintings subject to ever-more strenuous questions of quality and authenticity. The problem is not so much in the inevitability of name recognition, but in realizing that these artists tend to attract all the eyeballs and the crowds, usually at the expense of everything else in the room. We now take this stamp of genius for granted and don't look with due diligence.

Often just starting with who the artist was, what the title is and when the work was made is a good enough foundation in which to ground your appreciation. Perhaps an extra bit of information on a wall label might supply a few salient points, or maybe the iconography of the story is obvious enough to appreciate without reading further. However, there will always be times when you are faced with an obscure biblical passage or a mythological scene that baffles you, in which case it is better to use your own faculties and trust your instincts than to start hunting down more text – always read the picture first, then the blurb.

Art meets politics in this campaigning piece painted a few years after the French Revolution. The artist, Jacques-Louis David, was more or less the regime's Minister of Propaganda, organizing pageants and ceremonies for his brothers-in-arms after their great victory over the monarchy. So it should come as no surprise that this portrait of 'friend of the people' Jean-Paul Marat (below) depicts his martyrdom in a dramatic, heroicizing light. Marat was killed in his medicinal bath (he was afflicted with a painful skin condition) at the hand of a young woman who tricked him into giving her an audience using the false letter he appears to be holding. Yet despite his obvious ill state and the

Jacques-Louis David,
The Death of Marat, 1793.
Royal Museums of Fine Arts
of Belgium, Brussels

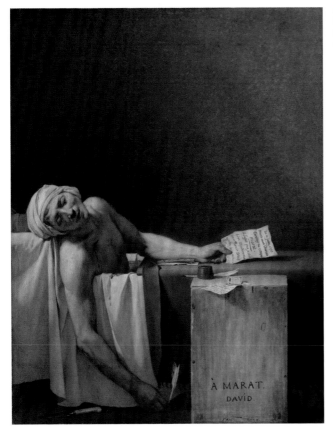

vinegar-soaked head wrap, Marat's countenance is one of grace in death, with a serene, smooth, unblemished face harking back to the idealized features of a Greek or Roman statue. His slumped form is modelled on none other than Christ himself, in a pose usually associated with Michelangelo's famous *Pietà* (1498–99) in Rome. Rather than the specific story of Marat's death (of which various facts have been unceremoniously changed), it is this background that David wanted to evoke in his attempt to convey the struggle and suffering of the everyman – that many centuries of previous art were leading up to this moment and validating not only his image, but also Marat's final moments.

Paolo di Dono, called Uccello, *The Hunt in the Forest*, c. 1465–70. Ashmolean Museum, University of Oxford

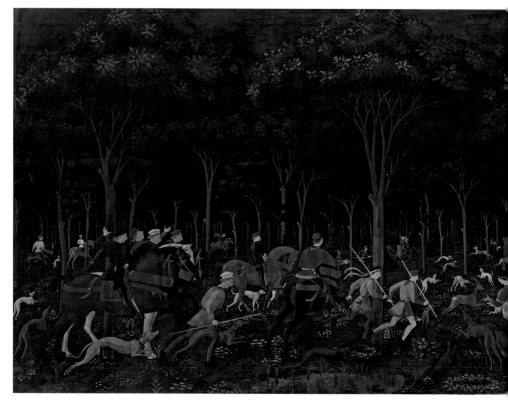

Look Again

Paintings of the past tend not to reveal themselves in 'Eureka!'-style leaps of understanding, but in glimpses, details, and through dedicated gazing. However, by this point – four steps into this soon-to-be unconscious process – the significance or otherwise of the work is beginning to form in your mind. You have allowed your eyes and mind to settle into the task at hand and given the picture a few moments to sink in. Perhaps you have been hooked by something in the story or by one of the players, and have stripped away the difficulties in order to ascertain a little of the who, what, where, and even a little of the why.

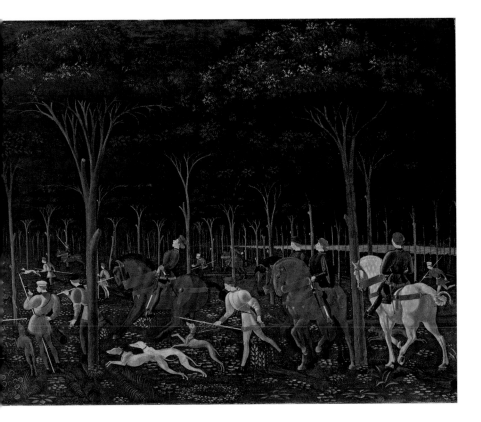

These might be only general thoughts on what makes this picture one of significance or a creeping suspicion that, conversely, it isn't worth the space it has been given on the wall. Whatever your half-time conclusions are, if you are hovering anywhere in this realm, then count it as progress; you have had a good first impression or found a foothold from which to grapple with the next level of comprehension. It is rare that these instincts aren't at least part of the way right the first time around, but, if in doubt, then move on to the next stage.

Spotlight on Understand

A group of hunters charge into a dark woodland, their horses either being restrained or leaping into the fray, while the dogs yank at their leashes or streak off into the distance towards an unknown prey. Similarly, a strange push and pull takes place within this elongated composition (ill. pp. 20–21), between its flat, tapestry-like arrangement and three-dimensional feat of perspective. Two horizontal bands delineate the foreground – the leaves in the trees sparkling with flecks of gold, while the red highlights of the huntsmen's jerkins and bridle gear punctuate the section below. Yet, within the central line of receding tree trunks, there appears to be a black hole sucking everything towards it, forcing a headlong rush into the unknown, as though the artist Paolo Uccello were trying to drag his colleagues out of the dark ages into a new era solely through his innovative use of perspective. Perhaps this painting would have looked like 3D cinema or virtual reality in the mid-15th century, representing the shift from shallow, decorative friezes to depth-filled theatrical space. That may indeed be all one can truly understand about this painting, whose inky patches of missing knowledge will always remain something of a mystery, or a nocturnal puzzle.

Of all the steps in this formula, this is one to remember not to forget. Like seeking a second opinion (which you can do if you are with someone else), this second look is essentially to ask yourself: what did I miss first time round? Did I think too fast, was my initial assumption correct? We are all prone to judge a book by its cover, but looking again is an acceptance that what we think we have seen may not be entirely straightforward. No matter that Old Masters are generally figurative and easily legible for the layperson, they can also be riddled with innuendo and information that requires further scrutiny. It is entirely possible to misread a gesture or an expression, or to fail to notice how a landscape is more than a mere backdrop. What is the significance of that prominently placed candle, the ornate clothing, or the sitter's ostentatious accoutrements?

A seemingly innocent scene can quickly turn dramatic or sour in this moment of renewed clarity – your enjoyment of a painting can hinge on the smallest detail, which in turn brings a new dawn of understanding. This is also an entreaty to return to works of art over and over again. Those that guard their secrets well will always hold a fascination for new viewers, eager to make that journey of discovery for themselves. Even the most famous works – I hesitate to invoke Leonardo da Vinci's much-discussed image of the Mona Lisa here, as it is just one example of this kind of iconic, postcard-ready picture – should be subjected to much more than a quick glance.

Spotlight on Look Again
This duet, of two portraits facing one another (ill. p. 24), is the perfect excuse for looking again. What might appear to be straightforward depictions of a father and son, with their professions clearly visible beneath their likenesses – the younger figure an architect, judging by the measuring device of the compass and his quill; the other, older man a musician, above a sheet of sophisticated notation – are actually two separate pictures, painted at different times.

Both panels have been framed together, but little unifying additions, such as the slightly misaligned stripes on the shelf below and the tufts of cloud linking the skies above, suggest they have been conjoined at a later date. The son (probably painted first) doesn't quite make eye contact with his pater, as his gaze is slowly twisting outwards to meet the audience.

This would have been a wholly innovative style of portraiture, whereas the older man is depicted in strict profile, as befitting official imagery commemorating elder statesmen on coins, medals and the like. It has been suggested that the father was painted after his death, given this death-mask profile and his sunken cheeks. Further inspection reveals that the father too had been in the building trade and might also be playing the organ in the background, suggesting this was painted as a mark of respect by a doting son who wanted his father to be seen alongside him in perpetuity.

Piero di Cosimo, *Portraits of Giuliano and Francesco Giamberti da Sangallo*, 1482–85. Rijksmuseum, Amsterdam

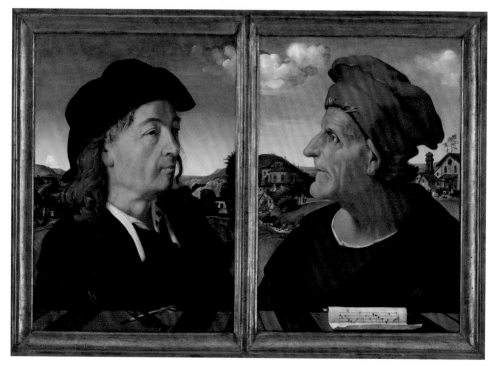

Look Again

It is time to take stock and make up your mind as to whether the work of art in question works for you, or not. Art's subjective nature – beautiful to some, an aberration to others – means that there is no right or wrong answer. Hopefully this process, which could just as well apply to any act of visual appreciation, should take no longer than necessary, nor should it become a barrier to enjoyment or constitute a chore. Much of the analytical technique outlined above is instinctual, so that it can be easily practised, quickly honed and shortened or lengthened according to one's experience or familiarity with an image.

Then again, maybe there was not enough Time, or you found no meaningful Association to connect with. Perhaps you are alone in a church staring at an altarpiece, for example, with no Background to speak of and therefore little hope of any quick Understanding. Maybe you took a few moments to Look Again, but found no reason to dwell even on the second time of asking. This is an admission that the formula can fail. So, of all the steps in this mnemonic to forgo, this – Assessment – is probably the one, because looking at art is not about coming to any definite conclusions. You can never be truly finished with a work of art, no matter how familiar it seems. Instead, decide if there is more to be learnt, or if it is better to walk away. This is not the final roll of the dice, however. Helping to finish the job is a further set of prompts, tailored to the specific conditions of looking at Old Masters, which can be harder to like or read than contemporary art. Their traditions, tastes and pictorial norms have changed so radically since their creation as to seem largely alien to our eyes.

Spotlight on Assessment
There can be no better imagery to pit your skills of assessment against in the whole of art history than that of the ultimate reckoning: the Last Judgment itself, when God casts souls to hell or brings them up into heaven. Which way will the work of art you are contemplating go? How do you even begin to judge the work: by its technical proficiency, effect, ideas or the connection it makes to you? Certainly, all of the above would be a start, and here, in a painting by Jan van Eyck (ill. pp. 26, 27), we have talent and craft in abundance (these are highly involved and detailed scenes for such a tiny pair of paintings, each just 20 cm, or 8 in., wide),

as well as compositional power and emotional impact that are far from proportionate to their small size. Yet despite its obvious brilliance, the treatment of the thronging mourners and soldiers of *The Crucifixion* on the left is perhaps not as original or captivating as that of *The Last Judgment* on the right (see detail, opposite), in which ranks of angels fan out above a winged death's head, guarding the underworld (it has been suggested that the diptych is missing a third, possibly central, panel). The subject matter may not grip the contemporary viewer, but the intricacies and deft touches should be assurances enough that these two panels are indeed masterpieces to behold. But each assessment is personal and subjective, so after walking around the painting and tabulating its merits, try to interrogate further by moving beyond the blank slate to the next stage of appreciation: the R.A.S.A.

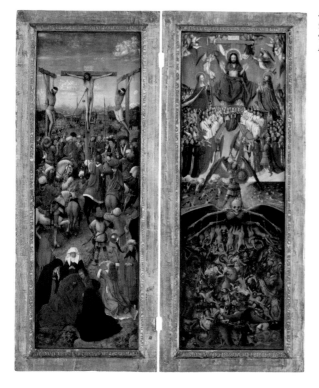

Jan van Eyck, *The Crucifixion;*
The Last Judgment, c. 1440–41.
The Metropolitan Museum of
Art, New York

Look Again

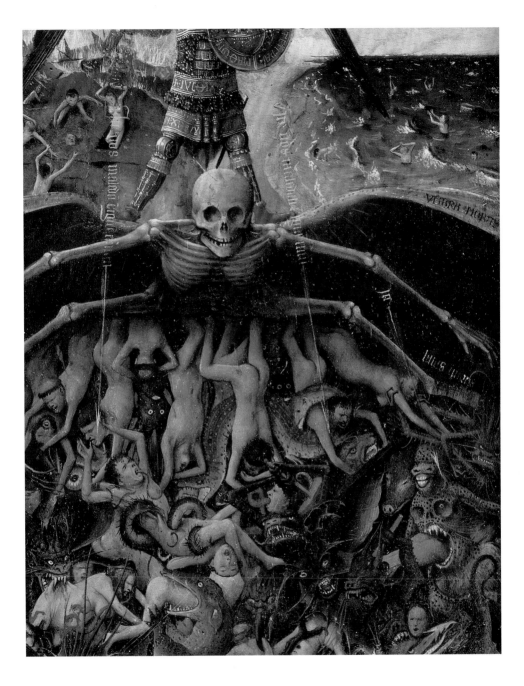

R.A.S.A.

Initially designed to tackle anything difficult or complex made since the millennium, the T.A.B.U.L.A. formula needed to encompass a vast modern-art practice that is fast becoming an almost 1:1 scale map of contemporary being – a wide-open field that mirrors all the materials, thoughts, attitudes, gestures and queries of life. That state of readiness to encounter contemporary art in any shape or form can now be handed down to focus on the particular demands of the art of the past.

This approach is still applicable to historical art, requiring as it does an element of interaction, of image absorption, a quick scan for information and a grasp of its context or message. The quickness of thought required to swiftly assess any work of art in this way allows the viewer to read pictures relatively speedily, before any meaning can be gleaned. But after that initial tabulation method – the stripping away of those barriers to seeing and understanding – comes the filling in of the slate and a closer reading of its contents, which is especially important when it comes to the Old Masters.

Given the already hushed environs of the old-fashioned picture gallery, you might have thought that there was less of a need to slow down and concentrate on the individual elements within a painting – that somehow this would be more straightforward or easier to decipher than any work of contemporary art. However, the specifics of looking at a painting can be likened to the act of making one – dedication and inspiration are required, while an accumulation of experience will always make the rewards and results much richer. With this in mind, an extra level of visual training is suggested here by the mnemonic R.A.S.A., which stands for Rhythm, Allegory, Structure and Atmosphere.

The musical connotation of the word 'rhythm' is no mere coincidence, as many of the characteristics of a piece of music – including its arrangement, harmony, tonality and both low and high notes – can be applied to the considerations needed to appreciate a painting. Each composition is governed by its ebbs and flows, its syncopation and its individual punctuations. These top notes can cause a painting to sparkle, to undulate or even to appear as though it were coming to life. While this might describe elements of a staccato, impulsive and fast-paced painting, other pieces have a sombre, flat key, or a base note, if you will, made up of only subtle gradations and a single speed. Whether quick or slow, crescendoing or flatlining, each picture undeniably has its own rhythm.

While we will come shortly to the more formal and rigid calibration of clarity, order and design (under S for Structure), the idea of rhythm is looser and based on an overall unity or pattern to a picture. Again, this relies more on a gut feeling and emotional reaction than to any rationale, allowing you first to be convinced by the rhythmic nature of a work before advancing to the more rigorous next steps.

A bodily, rhythmic response should also be taken into account when approaching a painting. For instance, does a work invite its own movement around it, or does it throw you off balance? A giant historical composition might warrant a fair amount of pacing up and down and, let's not forget, left and right, forward and backward, in order to appreciate its underlying pulse. Smaller paintings, too, can benefit from both close scrutiny and the view from a distance in order to absorb the dance of light, shade, character, landscape, gesture and story within each picture.

Spotlight on Rhythm

Very few images are as symphonic, or as famous, as *The Last Supper* (ill. p. 30), Leonardo's masterpiece painted on the wall of a refectory in a Milanese church. Like a site-specific installation, the space depicted mirrors the architecture below, as though Jesus and his apostles were sat in the very same eatery. Above the table, numerous apertures in the form of windows and doors provide some of the background rhythm. Below, we see the table legs appearing at regular intervals like a metronome, with the sitters' legs creating the 'off-beats' in between. The real drivers

in the painting are the writhing groups of figures centred around the static fulcrum of Christ: reading right to left, the furthest grouping is the most inward-looking, the next closest leans in as if to listen to the declaration of his betrayal; the first group to the left of Jesus recoils away, with the traitor in their midst, while the final trio of heads forces our gaze back along the line. Leonardo's tumbling, naturalistic depiction of gestures and figures promotes this flow of whispers, glances, facial contortions and the general sense of a whirl of interactions. Yet, as we know Leonardo's measurements to be based not just on scientific principles, but also, in the case of *The Last Supper*, on the ratios found in musical harmonies, it is clear that every single element – from the scattered bread rolls to the interplay of gesturing hands – adds its own flourish to the totality, yet serves to focus our attention wholly on the man in the middle.

Leonardo da Vinci, *The Last Supper*, 1494–98. Church of Santa Maria delle Grazie, Milan

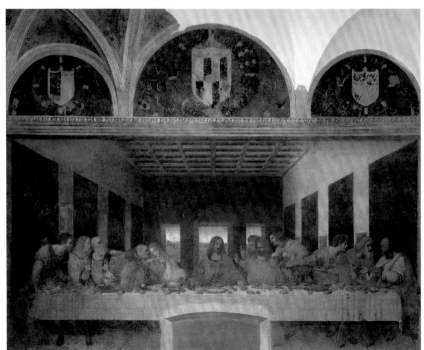

Look Again

An allegory is more than a mere backstory, although Old Masters collectively contain an abundance of mythical fables, legendary heroics, biblical passages and tales of moral instruction. As so many of these narratives are unfamiliar to our contemporary eyes and frames of reference – having long since passed into obscurity or simply gone out of fashion or out of print – this step is not an attempt to translate this cornucopia of world culture, classical literature and oral folklore, but rather to read into the signs, symbols and significance lurking beneath the skin of a painting.

The metaphorical transmogrification of objects, people or ideas into other forms is the typical trick of the allegorical artist. A pictorial stand-in or impostor might seem to be denying or distorting our view of things, but it can also impart new realities, allowing images another calling beyond simple legibility. The use of allegory often reveals an artist's ability to tackle big ideas, to turn everyday subject matter into sophisticated iconography: the Old Masterly equivalent of conceptual art. And like that most cerebral of art forms, the allegory has near linguistic functions, enabling the transformation of flat images into hidden meanings. Our mission is to put words to pictures, to pull language from visuals.

Again, this need not entail an intimate knowledge of art history and its symbolic content. Instead, we must make our own connections, however personal or subjective. If a painting is truly timeless, it will find a way to speak to us – or, rather, we must meet it halfway, entering into a dialogue as if reaching back into time in search of meanings and details that apply to now.

Spotlight on Allegory
This small, whirling painting is a sketch for Giovanni Battista Tiepolo's most important commission (ill. p. 32), a decorative ceiling scheme in Würzburg, Germany, which measures around 600 m² (6,460 sq ft) and took up more than two years of the Venetian painter's life. In true allegorical style, every figure represents something greater than itself or refers directly to a celestial body. Apollo, the sun god, sits almost dead centre, while around him orbit the other planets: Mercury appears upside down, gesturing towards the middle; Venus and Mars sit on a dark cloud

below; while Diana, the goddess of the moon, is clearly identified by a small crescent shape above her head. On terra firma, around the four sides, are the four continents, represented by four figures. On the left is Asia atop an elephant; next is Africa surrounded by camel merchants; a native American presides over an alligator and cannibalism; while Europe is at the centre of all things cultured and civilized. Throw into this heady mix a large dose of Greek mythology – featuring the three sisters known as the Fates, among many other groupings – and it seems that Tiepolo has succeeded in encapsulating almost the entire universe, its faiths and people, within one painting and under one roof. Viewed through our contemporary lens, perhaps unaccustomed as we are to such intricate symbolism, this picture also serves as a portrayal of the times in which the artist was alive, during which colonialism, sexism, racism and expansionism all ran rife and unabated. It further serves as an allegory for how much things change and yet how much things stay the same.

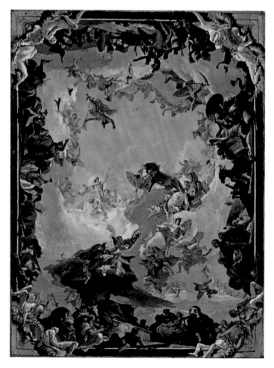

Giovanni Battista Tiepolo, *Allegory of the Planets and Continents*, 1752. The Metropolitan Museum of Art, New York

If the rhythm of a painting is its metre, its timbre, its background hum or overall movement, then the structure of a painting is its backbone, its building blocks, its foundations. These might be geometrical lines, shapes and partitions, or horizon lines and vanishing points – all ordering and controlling the gaze. The difference, then, between simply looking and really seeing a work of art is not just about staring longer or harder, but also about understanding how a picture is designed from the surface of the canvas up.

Most pictures are themselves already windows for looking into, rectilinear frames constraining the proportions of what is possible inside those four delimiting sides. But within the confines of that window exists an infinite range of potentialities, from the traditional life-drawing grid of squares within squares to great diagonal shafts of light or a discretely hidden central circle that draws the eye in and leads us around, the underlying structure acting upon us almost subconsciously.

Once the supporting structure reveals itself, this opens up the painting's hidden depths, the totality of its compositional glory. Then there is the three-dimensional organization of objects or bodies in space, which entails a foreground, background and middle ground. Along this axis, the players are variously positioned behind another invisible division – between them and us. Some artists have complete mastery over the internal workings of their world, employing a complex web of construction lines and organizing principles, while others prefer a less rigid approach with multiple focal points spread throughout an 'all-over' composition. Both approaches can lead the viewer happily towards concentration or distraction.

Spotlight on Structure
A semicircular sky frames this baptism scene by Piero della Francesca (ill. p. 34), but were you to complete the circle, the curvature would exactly follow the lines of the loincloth hugging Christ's waistline. An anchoring line can be drawn up vertically through his navel and praying hands, through to the tiny dribble of water cascading on to his head. The horizontal spread of the dove's wings (and a slip of cloud) bisect the circle, St John the Baptist's angled leg cuts the lower square perfectly in half, while his arm follows the opposite 45° axis down to the left-hand corner. And on

it goes, heaven and earth separated, the wild landscape in the background tamed by man's orderly conjunctions of angles and geometrical shapes in the foreground – yet Christ remains the serene constant. But instead of seeing the artist as a mathematician rather than a painter, consider how he draws lines through space, dragging us into the image, penetrating beyond his orderly grid of structuring lines to explore the meandering paths and hills in the distance. The third angel, too, draws our gaze, making eye contact in a way that pulls us further into Piero's world.

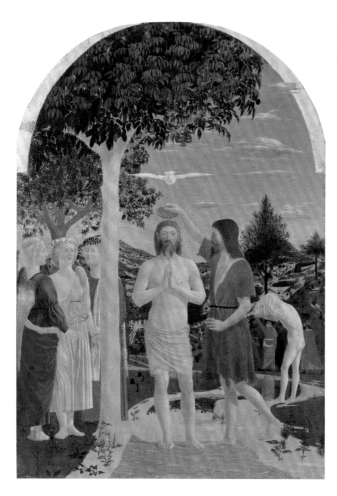

Piero della Francesca, *The Baptism of Christ*, after 1437. National Gallery, London

Look Again

After a work moves us (by means of Rhythm), once its details have astonished us (with Allegory) and its majesty has solidified in front of our very eyes (through its Structure), then what more of an effect can a work of art have on us? Often, when moved by a painting, we are left with the lingering sense of its influence or an afterglow: its Atmosphere. This could be the haze of smog hovering over Whistler's London, the monkish quietude of *St Jerome in his Study* by Antonello da Messina (*c.* 1475), the weight of menace in Goya's so-called Black Paintings, or the levity experienced in the soaring works of Tintoretto.

The atmosphere signifies the overarching tone of a picture, a residual sensation that is best experienced in the flesh, with the work in front of you. While reproductions in glossy books or in high definition promise better pixels-per-inch or screen resolution than is discernible to the naked eye, there is nothing like physical proximity with a work of the past. Its true atmosphere is much harder to gauge when looking at a flat image in a book. The texture, the play of light on the surface, the touch of the artist and the dimensions in relation to your body are all lost when considering a painting through a backlit screen or your camera's zoom function. In person, a work either has or doesn't have real presence – it will either hit you or it won't, at which point you can move on.

And move on we shall, from this final step to some wider themes and further possible ways into specific works of art in the following chapters. For example, the first chapter looks at ideas in art as far back as medieval times and the second at how a faithful reproduction of a bygone era might spark a reaction in a viewer many centuries later. From Philosophy to Honesty and the ideas behind the pictures, there are then chapters on Drama, Beauty, Horror and Paradox, in which many styles, movements and eras might clash, even on one canvas. Finally we leap from Folly to Vision, from the jokers and the madmen to the sages and the prophets, with a concluding word on the artists that preceded and indeed predicted our modern world through their works.

An explosion of yellow all but obliterates the sky and everything beneath it. Only the blue-tinged shadow of the ruins of a castle and a barely described cow momentarily block the blinding light. J. M. W. Turner returned to this landscape on the borders of Scotland throughout his life, but didn't need a return visit for the realization of *Norham Castle, Sunrise* (opposite), seemingly basing it on sheer memory and his mastery of painterly and chromatic effects. Turner never exhibited this painting, leading many to believe he left it unfinished in his senior years. And yet its atmospheric glory burns perhaps even brighter today, now that it is rightly considered as one of his greatest pictorial achievements, precisely because of its very abstraction and lack of finish.

Whether or not Turner really bowed and doffed his cap in the presence of this castle view on one apocryphal visit, or famously declared that 'the sun is God' on his death bed, he undoubtedly worshipped the power of nature and the influence it exerted on himself and others, much as he sought to move people through his art. By dispensing with the trappings of the visible and succumbing to pure sensation and emotion, this painting radiates hope and warmth, while promoting the notion that art should be felt and not just seen. Turner didn't merely prefigure or invent abstract art, he understood that the goal of an artist should be to change perceptions, not mimic them; to suggest entirely new responses to the world that couldn't be quantified, measured or recorded by any other means. His language was atmosphere.

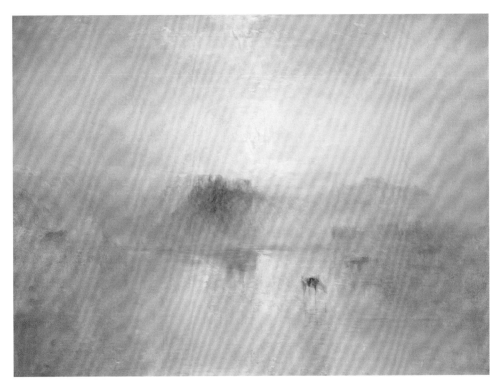

J. M. W. Turner, *Norham Castle, Sunrise*, c. 1845. Tate, London

Chapter 1
Art as Philosophy

Only a person who has himself experienced the impact of a fertile idea will understand what passionate activity is stirred in our minds. *Johann Wolfgang von Goethe, 1831*

The history of art is also the history of philosophical thought, and the Old Masters specialized in the exploration of life's so-called 'big' questions. Why are we here? Who put us here? What constitutes life? Who governs our minds and everything else around us? Enquiries of such biblical proportions are also pitted alongside more worldly concerns, including the perception of beauty, truth and justice, which will form the basis to some of the chapters to come, each one intended as a guide towards a different level of understanding the art of the past.

Artistic expression is as often the transmission of ideas as it is of images. Long before the idea itself became a work of art during the heyday of conceptual art in the 1960s, artists were laying bare the workings of their minds – their innermost desires, fears and metaphysical quandaries – through the pictorial translation of such notions into people, places and situations. These centuries-old artworks can still provide spaces for contemplation and arenas for clarity or uncertainty.

In *Landscape with St John on Patmos* (1640; opposite) by Nicolas Poussin, we see a holy man in a landscape of ruins writing his final and most fiery words, better known as the Book of Revelation. Yet we see no apocalyptic visions of four marauding horsemen or the sun becoming 'black as sackcloth of hair, and the moon like blood' (Revelation 6:12). Instead, the holy man sits quietly and alone, while constructing this most violent of texts, symbolizing the overthrow of the previous world order – seen in the Greek and Roman remains littering the surroundings – in favour of the progressive New Testament. Although Poussin reveals something of his own philosophical leanings towards Stoicism, or the suppression of emotions in favour of an undying faith in God, as well as

the idea of *logos* – the divine organizing spirit at the core of the universe – he is also depicting the ultimate stoic act, in which St John is lost in thought, even while being plagued by an invisible vortex of inner turmoil.

A more literal depiction of the tenets of ancient philosophy can be seen in Raphael's fresco known as *The School of Athens* (1508–11; ill. pp. 40, 41), located in the Vatican (although there is a passable life-size copy at the Victoria & Albert Museum in London, painted by Anton Raphael Mengs). This homage to the many and varied ideologies of the day includes all the great Greek and Roman thinkers – from Socrates reading studiously on the left, to Euclid (or perhaps Archimedes) marking

Nicolas Poussin, *Landscape with St John on Patmos*, 1640. Art Institute of Chicago

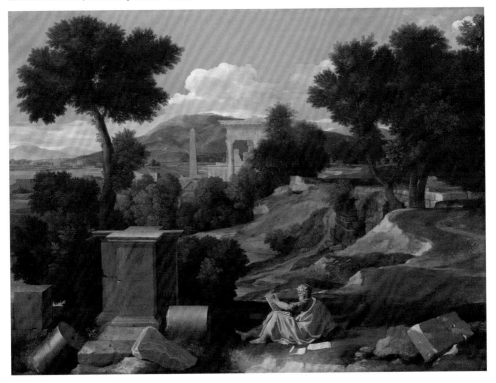

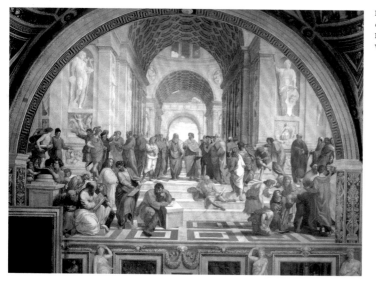

out a geometrical symbol on the right. In the centre stand the figures of Plato, pointing up to heaven to indicate his belief in the power of the abstract idea, and Aristotle, who gestures towards the earth and his preferred focus on the concrete and physical sciences. Nowadays this heady roll call is nearly impossible to complete by name and hardly the point for the contemporary viewer, although worth noting among the crowd are Raphael's likenesses of his artistic colleagues and counterparts, including Michelangelo, leaning on a block of marble; Leonardo masquerading as Plato (see detail, opposite) and the artist himself, staring out from the behind the right side of the arch in a black beret. Besides Raphael's painterly grandstanding, we are left with an overwhelming impression of man's broad base of knowledge, shared across this dense frieze, representing all the wisdom of the ages, or man's progression towards a collective light-bulb moment.

Not all great thinkers have been immortalized by such great artists. The most famous portrait of the German giant of literature and Enlightenment thought, Johann Wolfgang von Goethe, at first appears to be little more than a fawning likeness of some kind of foppish, romantic rock star. Painted by a little-known artist, Johann Heinrich Wilhelm Tischbein, *Goethe in the Roman Campagna* (1787; ill. p. 42) is

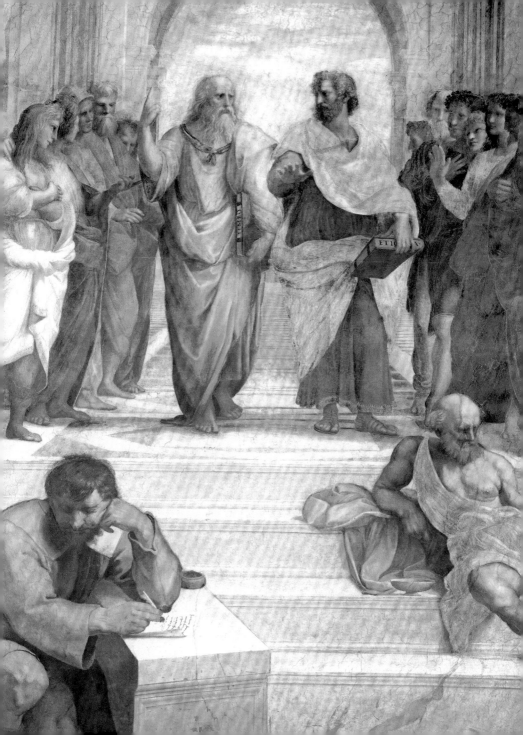

indeed a slightly comical image of fandom, with Goethe posing awkwardly in an Italianate setting. But Tischbein's saving grace is to equate some of his great idol's ideas about man's interconnectedness with nature into the composition – depicting Goethe at one with the landscape, his caped body and covered leg almost indistinguishable from the rolling hills beyond. Of course, thought-provoking art need not directly reference real philosophers, but it should lead to the viewer's own existential enquiries. Whiling away hours pondering the meaning of it all, like the lounging Goethe, is an exercise generally associated with the bone idle and the dreamy bohemian. Yet time spent looking and musing is never wasted; indeed, inactivity and even boredom can be useful when attempting to glean philosophical insights from a work of art.

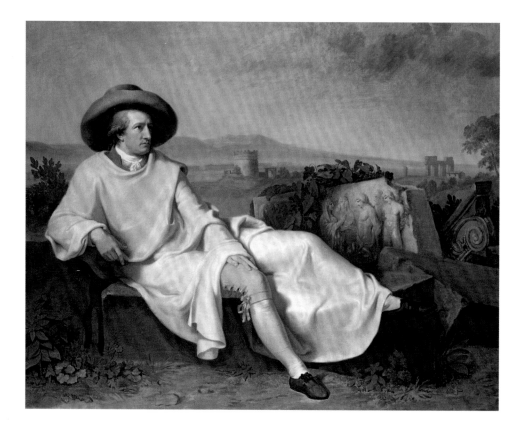

Albrecht Dürer, *Melencolia I*,
1514. The Metropolitan Museum
of Art, New York

Opposite Johann Heinrich
Wilhelm Tischbein, *Goethe
in the Roman Campagna*, 1787.
Städel Museum, Frankfurt

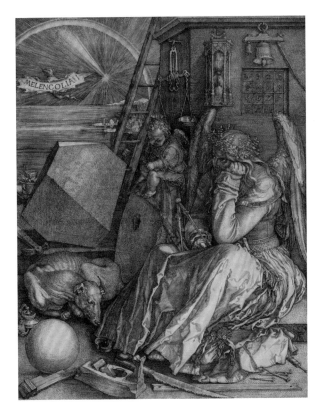

Take Albrecht Dürer's stunning engraving of inertia, entitled *Melencolia I* (1514; above), which shows a despondent angel, wings clipped by her sullen state, while a cherub looks on inconsolably and a faithful dog mirrors his mistress's low mood. Neither is her mind allowed to soar, given her inability to use the many measuring or crafting tools at her disposal, rendering the great wonders of the universe – seen above in a blazing sky adorned by a rainbow and a comet – as uninspiring, unfathomable mysteries. Often read as a self-portrait of Dürer's own tortured state of mind and struggle for creativity (something like writer's block), it is also the perfect graphic representation of the power of thought in art (witness the sudden flash of realization in the angel's eyes) to transcend the drudgery of everyday work, in pursuit of the endless possibilities of the imagination.

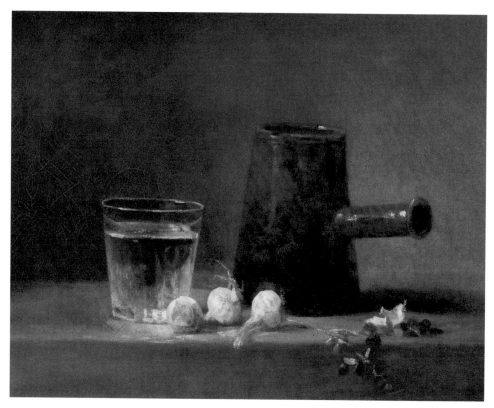

Jean-Baptiste-Siméon Chardin, *Glass of Water and Coffeepot*,
c. 1761. Carnegie Museum of Art, Pittsburgh

Even that drudgery, deemed the lowliest of subject matters for traditional painters – those quotidian scenes and simple objects arranged as still lifes or so-called 'genre' paintings – can be elevated by a philosophical underpinning. Jean-Baptiste-Siméon Chardin's seemingly innocuous *Glass of Water and Coffeepot* (*c*. 1761; opposite) shows only those items, plus three bulbs of garlic and a spray of herbs tumbling off a shelf. There is no frippery to this picture, nothing is wasted and no gesture is overplayed. It might even end there, were it not for the play of light on the rim of the glass and the echo of this circle in all the other circles swimming around on the surface.

While Chardin gives his objects almost physical solidity, this surety is contrasted with the negative spaces, shadows and voids beyond, which merge table and background into an abstract haze. Like Turner's *Norham Castle, Sunrise* (ill. p. 37), discussed in the introduction, under A for Atmosphere, these passages of ambiguity allow us to practise a different kind of open-ended thought, as well as offering us time and license to think freely (allowing me, for instance, to imagine this grouping as a family, if not exactly of figures, then at least as a metaphorical family of objects).

Even the humblest of things can be filled with potency, when laden with such symbolic weight and filled with allegory (to use another A in our mnemonic). Once alighted upon, it can seem as though any hidden message is being delivered by a blunt instrument, especially so in the case of a subset of the still-life genre, known as *vanitas*, from the Latin for emptiness, signifying the uselessness of worldly goods and the vanity of man in the face of certain death. An unmistakable example of this, Pieter Claesz's *Still Life with a Skull and a Writing Quill* (1628; overleaf), can be nothing else but a treatise on mortality, from the hollow cranium to the upturned glass, the inkwell left to dry and the candle having just snuffed itself out. The frayed and ragged papers beneath the quill are almost level with the looming precipice of the table's edge, which is further sharpened by a foreboding, final drop.

Every element within the painting leads us to the same, inevitable conclusion, but also serves as a reminder to the viewer that knowledge, literature and living by whatever credo has been put down in those books are surely worthwhile pursuits, even if only for a finite amount of time. Claesz, by placing the arts and the mind at the centre of his work, reveals himself as a philosopher-artist and more than merely an accomplished

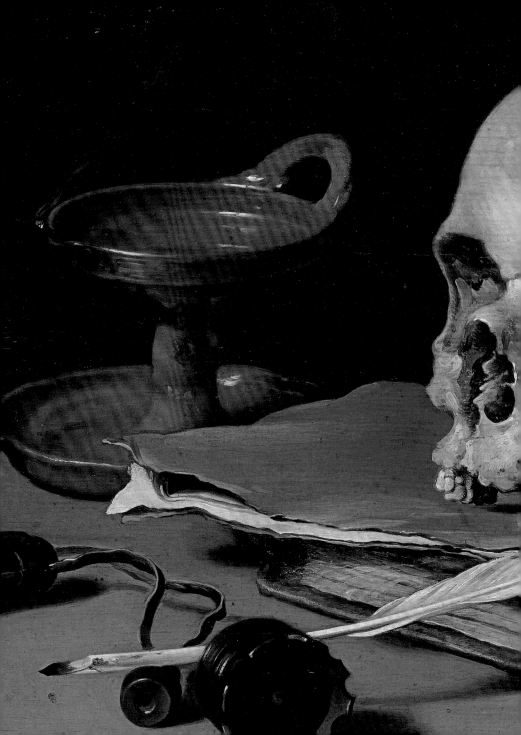

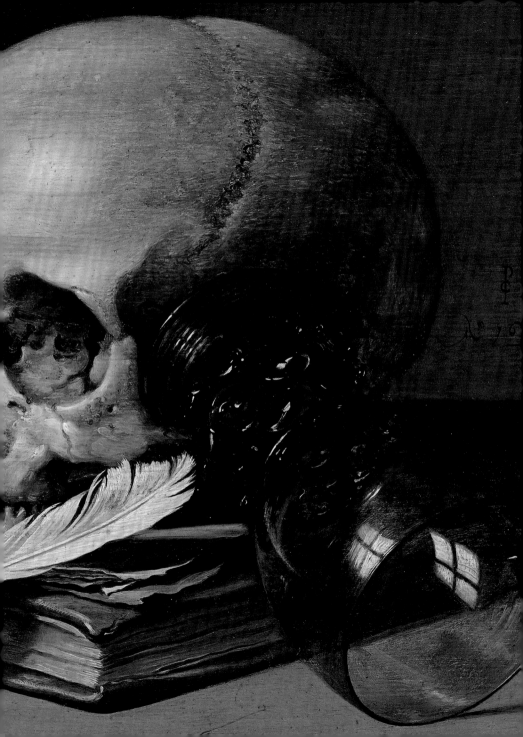

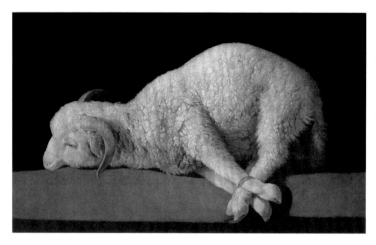

Francisco de Zurbarán,
Agnus Dei, 1635–40.
Museo del Prado, Madrid

Previous pages Pieter
Claesz, *Still Life
with a Skull and a
Writing Quill*, 1628.
The Metropolitan
Museum of Art, New York

painter of objects. The soft light on the skull's contours might even
suggest pensive clouds gathering in the brain and the mind's enduring
power if not to overcome death, then at least to keep morose thoughts
at bay and potentially immortalize the soul through the penning of a
book or the production of a work of art.

Another seemingly bleak portrayal of mortality, this time of the
impending demise of an animal, is Francisco de Zurbarán's *Agnus Dei*
(1635–40; above). Although similar in style to the still life or genre
painting (referred to in Spanish as a *bodegón*, meaning from the pantry
or the tavern), this could also be categorized as a *vanitas* image given its
omen of death, or even elevated to the status of serious religious subject
matter. Is it a crucifixion or the main course, you might ask? Is this
sacrificial lamb dying for our sins or for our supper?

A quick detour through the principles behind the R.A.S.A.
technique might be useful here to sort the culinary from the canonical.
The rhythm might seem to follow a single, strangulated note, with the
relentless blackness beyond framing the creature in a stark, frontal light,
as if in a photographer's studio. On closer inspection, the tufts of the
lamb's woollen coat create visual interest and provide some vestiges of
life, guiding the eye across the canvas, down to the lamb's bound feet.
Ultimately, this lower portion provides the claustrophobic crux of the
picture, where the legs criss-cross within the tightly framed composition,

providing what little structure there is to behold. Indeed, out of a dozen similar treatments of this subject, the artist has stripped this particular version down to its barest essentials, removing a halo from above the head and inscriptions from the grey slab, leaving little in the way of guidance for the curious viewer. The effects of atmosphere are also muted, the contrasting light and dark tones making the scene appear strangely theatrical and unnatural. The final recourse is to allegory, allowing us to break from the constraints of the visible and imagine the sacrificial lamb as the Son of God.

Such metaphorical allusion is a sure sign that a painting contains sophisticated thinking. Beyond the biblical reference to the man that died for our sins, or even the slain sheep as *nature morte*, reminding us of our own impermanence, Zurbarán's image can also be read as a positive emblem of the ties that bind us to the rest of humanity. Indeed, a truly philosophical painting is one that encourages more than one school of thought or one side of an argument, embracing ambiguity and possibility over instruction. The darkness of the background might signify death, while the whiteness of the lamb's coat implies life, suggesting that the entire meaning of a work might change, depending on your mood or your predisposition.

The Old Masters are rarely quite so black and white, however. Many force us to think by making us clamber through a complex web of symbols and dense combinations of allegories, as in another particularly puzzling painting by Poussin, known as *Et in Arcadia Ego* (1638–40; ill. pp. 50, 51). A group composed of three men and one woman huddle around a tomb, on which an inscription counterintuitively reads: 'I am now in paradise.' This seems a dark, funereal message to deliver in such a verdant landscape, until the epitaph (*Et in arcadia ego*) is transliterated from the Latin to read as either a humorous or ironic question: 'Am I now in paradise?'

The very notion of Utopia, or Arcadia, is just that: an idea, rather than a reality, one that perhaps we look for all our lives and can never hope to discover. Perhaps the work was painted for an ill man or in homage to someone recently deceased, and death himself is lurking in paradise ('Even here in Arcadia, I exist'). Or perhaps Poussin is playing an elaborate joke on the viewer and this is merely a sign denoting the location of the painting in Arcadia, an actual remote and idyllic area of the Peloponnese mountains of Greece.

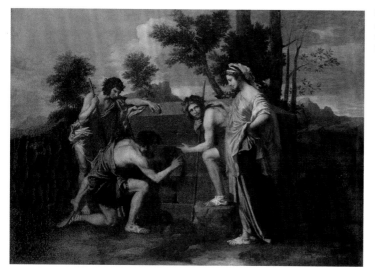

Nicolas Poussin, *The Arcadian Shepherds, or Et in Arcadia Ego*, 1638–40. Louvre, Paris

Just when there seems no clear way through to the understanding of a work of art, try using a different theory (*vitals*), which means 'way of seeing' in Greek. Again, the A for Allegory seems most apt here, with Poussin's shepherds standing in for the audience and both of the crouching figures pointing or following the letters with their fingers in an attempt to unravel this metaphorical mystery (see detail, opposite). In this tracing they are also recasting the first time anyone ever made a painting, according to the 1st-century philosopher Pliny the Elder's account of the origin of the artistic act, in which a lover outlined the shadow of her partner's face on to a wall, before he left on a long journey.

This very first and most basic image in the entire history of art is separated from the latest and most cultured only by the amount of thought that has gone into each subsequent work of art – including Poussin's multi-layered painting with its elliptical text, or, in our case, the contemporary and conceptual artworks that are just as likely to comprise words or ideas representing an internal state of mind, rather than anything resembling the world outside.

We tend to think of painting about painting, or art concerned with the ideas behind art, to be modern conceits, tautological pursuits dreamt up by 20th-century artists hellbent on breaking from tradition.

Look Again

But many of the Old Masters had long ago begun testing the intellectual possibilities of their medium. By filling their pictures with meanings and imbuing their figures and objects with symbolic potential, these artist-philosophers introduced allegory and intrigue into the realms of representation and decoration. Painting has always been more than a means of retelling ancient parables; it is in itself a mnemonic device for prompting deeply existential thoughts and for probing philosophical dilemmas. And the best of the Old Masters knew it, too.

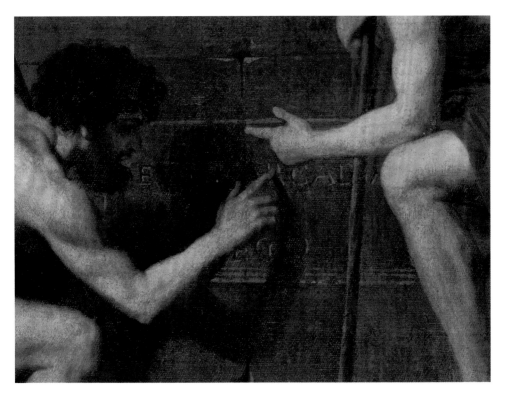

Chapter 2
Art as Honesty

Truth is the highest thing that man may keep.
Geoffrey Chaucer, c. 1390

In its most basic terms, when art comes closest to depicting reality, it supposedly succeeds – as tradition would have it – by presenting the audience with an accurate rendering of the visible world. This outward appearance can delight and even fool the eye, as it did in the fable by Pliny the Elder about Zeuxis, a painter in the 5th century BC, in which the artist so perfectly modelled a bunch of grapes with his brush that birds flew down in order to pluck them from his freshly painted panel.

Such skill is to be lauded in art, but a simple reflection of reality can do little more than mirror what is already there. Unlike the works in the previous chapter, which sparked human thought through complex combinations of form and imagery, a picture that is a mere double of its subject matter creates an impressive illusion of reality, but fails to interrogate that scene's meaning or reveal anything other than its likeness. Imitation may well require the highest form of artistic dexterity, but as an art form, the slavish copy does not necessarily lift the spirit.

At least that is what I assumed, before travelling to Spain to see a number of beautiful polychrome wooden sculptures of Virgins or Christ figures as they were meant to be seen – in processions or as aids to religious celebrations around Easter or various saints' days. The function of these intricate pine, cedar or cypress carvings was to be hyper-real in every detail – from their inlaid glass eyes and crystal tears, down to the painted trickles of blood issuing from lifelike stigmata wounds – in order to stir the congregations towards faith-induced fervour. Removed from their altarpiece perches in Seville or from swaying hypnotically upon the shoulders of the devoted *costaleros* (float bearers) on Palm Sunday, these icons were then shipped to London to be exhibited at the National Gallery for a stunning exhibition entitled *The Sacred Made Real* in 2009–10.

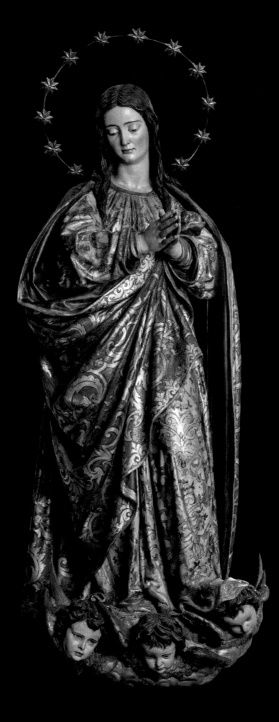

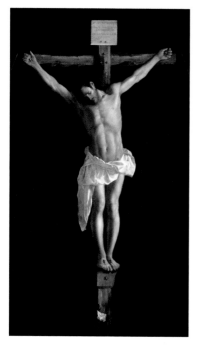

Francisco de Zurbarán,
The Crucifixion, 1627.
Art Institute of Chicago

Previous page Attributed
to Juan Martínez Montañés
and unknown painter, *The
Virgin of the Immaculate
Conception*, c. 1628. Church
of the Anunciación, Seville
University

Here, in theatrically lit surroundings, were the same monks, priests, Madonnas, Christs and saints, stood side by side with the great Spanish painters they had been inspired by or had themselves influenced. A famous picture by Diego Velázquez of the Immaculate Conception (1618–19), with the Virgin clasping her hands in the same pose as the nearby three-dimensional statue sculpted by Juan Martínez Montañés (ill. p. 53), just a decade later, suggested, even to an atheist like me, that witnessing such skilfully modelled effigies could lead to a belief in the transfiguration of wood and paint into flesh.

These highly realistic figurines, rather than kitsch imitations of life, suggest the possibility of human interaction or connection with our idols. It would be at least another 200 years before a different form of realism – the invention of photography – could deliver the same degree of verisimilitude or truth to likeness. Rather than consistently striving to achieve the ultimate facsimile, however, history's greatest artists have instead been searching for an altogether more authentic kind of honesty.

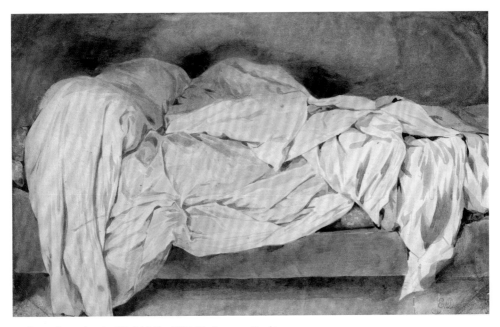

Eugène Delacroix, *Le Lit Défait*, 1825–28. Louvre, Paris

In the same year that the first photograph was taken by Joseph
Nicéphore Niépce, another Frenchman, Eugène Delacroix, made
a realistic watercolour study of an excruciatingly private revelation –
the dishevelled sight of his own unmade bed in the morning, simply titled
Le Lit Défait (1825–28; above) – seemingly choosing to paint a subject
so commonplace that the very idea of picking up a brush or pressing
the shutter to record such an inconsequential moment might never have
occurred to anyone before or since. Except that the unmade bed now
has an indelible association with contemporary art, from Tracey Emin's
installation of her own soiled bedclothes, mattress and associated detritus
(*My Bed*, 1988) to the AIDS-inflected photograph of the impression left
on a pillow by a lost lover (*Untitled*, 1991), made by the American artist
Felix Gonzalez-Torres.

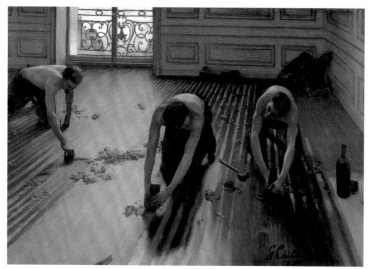

Gustave Caillebotte,
The Floor Planers, 1875.
Musée d'Orsay, Paris

Below Gustave
Caillebotte, *Paris
Street; Rainy Day*,
1877. Art Institute
of Chicago

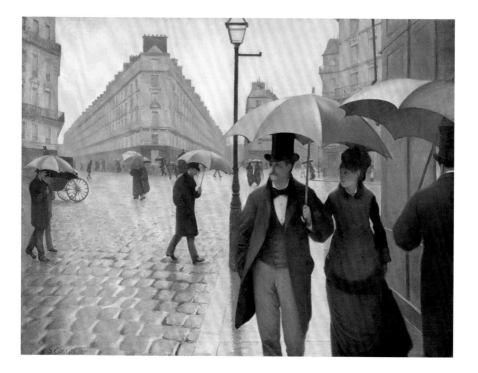

Look Again

What makes the original version by Delacroix similarly heartbreaking is that it, too, might have been considered as something of a throwaway self-portrait, admitting that this famous painter of passion, politics and violence, with his swaggering dandy persona, may have actually been lonely and reclusive. The crumpled heap of sheets has echoes of a human form, ghostly shapes that recall the figure of a murdered concubine sprawled over a bed in an epic Delacroix history painting of the same year, *The Death of Sardanapalus* (1827), but rather than a mere study towards this larger work, I prefer to see the watercolour as its own miniature tale of sorrow and honesty. Capturing truth and universality is clearly not just about exactitude or fidelity to nature, but also about understanding the meaning of objects or situations in front of us in plain and unsentimental terms.

Although the unmade bed was never destined for the walls of the Paris Salon, or perhaps even for public consumption, the 19th century saw many more artists explore this new mode of realism, once again depicting the simplest subjects with renewed heroism. In Gustave Caillebotte's *The Floor Planers* (1875; opposite, above), three workers in the act of stripping floorboards are not only deemed worthy subject matter for painting, but are also elevated to artisans, capable of producing their own moment of eternal glory. As in another of his most famous images, *Paris Street; Rainy Day* (1877; opposite, below), in which Caillebotte translates an ordinary boulevard into a composition of reflective light and magical realism, his paintings achieve a transcendental kind of honesty.

The rise of gritty social realism in the 1850s – depicting peasants, farmhands, stonebreakers – brought about a reassessment of the status of the marginalized classes in society, harking back to a simpler, agrarian state, before the Industrial Revolution. Of course, this was not the first time such images had been popular: Pieter Bruegel the Elder had painted one of the first and finest explorations of such hard graft three centuries before. His magnificent composition, *The Harvesters* (1565; ill. pp. 58, 59), one of a six-part series about the changing seasons, depicts the labour required to bring bread from glowing wheatfields to the table, from the scything and reaping of the crops to the bundling of the stalks left out to dry. Beyond the toil, the peasant workforce are also seen relaxing beneath a tree, joking, drinking and eating – the process of work, repose and recuperation mimicking the whole process of turning wheat to sheaf, to grain, to bread and finally, to beer and to the belly.

We shall see the use of comedy reappear in this artist's armoury in a later chapter, but here the drunken napping figure at the centre, underneath a pear tree (see detail, opposite), is not just a figure of fun, but also one of sheer exhaustion, caused by a morning of hard work. Three centuries before Caillebotte's floor planers, Bruegel depicted the reality of labour without the heroics. Indeed, while the workers strive at the foot of the image, the symbols of religion, trade and land ownership peek through the foliage above, as far as the ships setting sail on the high seas. These loftier elements seem to inhabit a different world, separated by the horizontal bands of wheat in the valley below.

Pieter Bruegel the Elder, *The Harvesters*, 1565.
The Metropolitan Museum of Art, New York

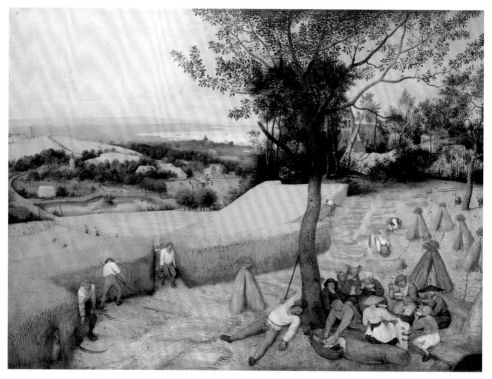

Look Again

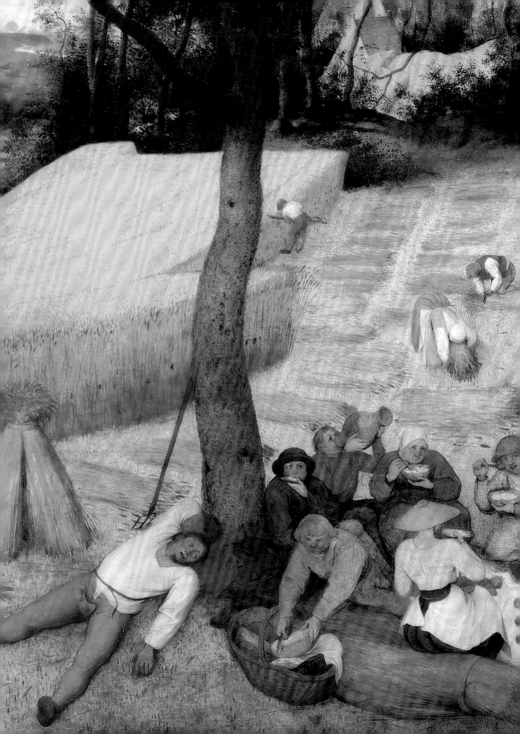

If honesty in art is to paint images that are true to life and matter of fact, it is also to state that the veracity of an artist's hand need not be refuted; it's so realistic, in other words, that it couldn't possibly have been made up. There is something so lowly about the whole genre of pastoral realism, or the depiction of landscapes and rural settings in general, that these pictures can seem plain and mundane, when often they are simply too honest for their own good. I am thinking here of many Dutch artists including Aelbert Cuyp, whose *Herdsmen with Cows* (mid-1640s; below) shows only the seemingly banal scenario described by the title. A matter of pride for this farmer's son, Cuyp presents the cattle as noble beasts and symbols of national prosperity in their robust and healthy state. Silhouetted against the sky in a raking, yellow light,

Aelbert Cuyp, *Herdsmen with Cows*, mid–1640s.
Dulwich Picture Library, London

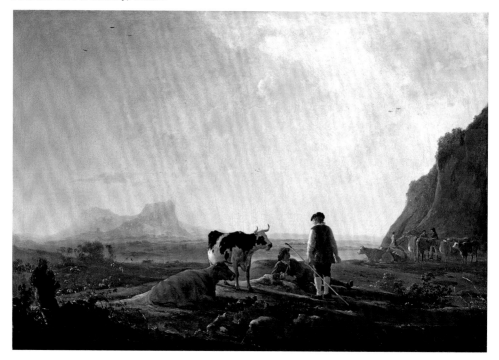

Look Again

this idyllic concoction might seem like an impossibly heroicized image of rural reality, but provincial and down-to-earth subject matter was rarely given such meticulous artistic attention. Cuyp is even careful to depict his beloved lowlands in all their flat and unremarkable glory, without recourse to unfaithfully dramatic alterations.

Another painter from the Netherlands of simple, everyday scenes was Pieter de Hooch, whose interiors captured a world normally concealed behind the closed doors of typical Dutch households. Whether mopping the floors, buttering bread, breastfeeding a baby or delousing a child's hair (as seen in the painting below), de Hooch's protagonists are forever subsumed by their surroundings and interminable chores, unlike another of his compatriots, Johannes Vermeer, whose graceful figures and psychological innerworkings loomed larger than their surroundings.

Pieter de Hooch, *A Mother Delousing her Child's Hair,* known as 'A Mother's Duty', c. 1658–60. Rijksmuseum, Amsterdam

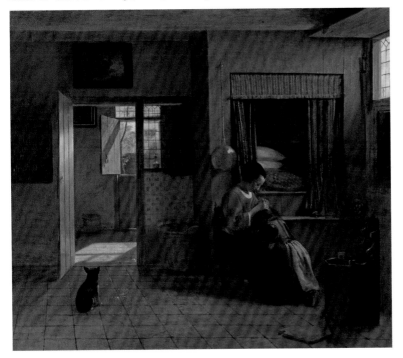

A master at controlling the light effects and the atmosphere of a domestic interior, de Hooch – even more so than Vermeer – created perfect, jewel-like boxes within boxes, of rooms leading to rooms with views to, perhaps, a modest courtyard or a glimpse of sky, all the while painting surfaces that you feel you could touch, or doorways you could step into. These were not so much still lifes but lives stilled, captured in freeze-frame and preserved as if in aspic, down to the very last detail, including every cracked floor tile, scullery bucket and chamber pot. The spotless interiors de Hooch painted might strike a false note of faultlessness for some viewers, but clearly cleanliness was close to godliness for the women that he concentrated his brushes on – either reinforcing the male-dominated society of the time or empowering these stoic figures with a sense of purpose and belonging, depending on your personal point of view.

The pre-eminent painter of vistas of almost any kind, although he traded mainly in sweeping views of Venice and its waterways, was aptly named Giovanni Antonio Canal, or Canaletto. It is now well known that he would often forgo accuracy in favour of pictorial harmony, no doubt in order to better sell his desirable wares overseas (as indeed many artists would), but his sheer love of detail is near unsurpassed in the history of art, making each picture a visual delight, if not always an entirely honest one. Yet, in a relatively early image, titled *The Stonemason's Yard* (*c*. 1725; opposite), Canaletto chose an unfashionable and gritty scenario to illuminate the to-ing and fro-ing of everyday folk, from those hard at work fashioning great lumps of Istrian white stone for a new church, to the gondoliers and washerwomen going about their daily routines. Maybe the backstage nature of this picture would have resonated with a local Venetian who was familiar with this less-polished corner of the city, but nevertheless the choice to paint such an untidy, humble setting shows a commitment to truth-telling beyond Canaletto's predilection for chocolate-box-pretty panoramas and his rumoured reliance on optical, pinhole camera-like devices.

In market terms, honesty is not always the best policy, with collectors and patrons preferring to hang saccharine-sweet confections (more of which can be found in the chapter dealing with Art as Folly) or uplifting, crowd-pleasing compositions on their walls, rather than anything approaching a brutally honest depiction of the world. Another artist known as much for his fictionalizing and fakery as his exactitude

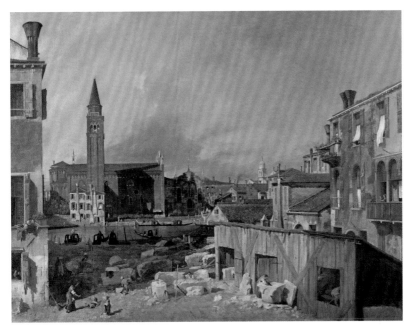

Canaletto, *The Stonemason's Yard*, c. 1725. National Gallery, London

with a brush was Canaletto's nephew and pupil, Bernardo Bellotto, who continued his uncle's lucrative trade in Venetian *vedute*, or view painting. While never creating anything remotely ugly, his astonishing *Ruins of the Old Kreuzkirche, Dresden* (1765; overleaf) goes even further than his master in the depiction of the chaos of rubble and dust. Bellotto meticulously recorded the wrecked gothic façade of the Church of the Holy Cross in Dresden, which had been recently destroyed by Prussian forces in the Seven Years' War, not to create a thing of beauty for his own prosperity, but as a document for posterity of a war crime that should not be forgotten. While he was surely moved by his good fortune not to be at home when his own house was razed in the same sacking of the city, we cannot help but recall the remarkably similar images capturing the wholesale destruction of Coventry and Dresden towards the end of the Second World War, allowing the viewer to time travel between 1765, 1945 and today.

Sir Joshua Reynolds,
Omai, c. 1776. Private
collection

Previous pages
Bernardo Bellotto,
*The Ruins of the
Old Kreuzkirche,
Dresden*, 1765.
Private collection

Look Again

Another kind of temporal shift occurs in works of art that have broken boundaries for frankly depicting black people or, indeed, anyone of a foreign or ethnic background, who were, at the time, either not considered suitable subject matter for paintings or were hitherto barely represented in any favourable or memorable way in the history of Western art. In 1774 a man known as Mai, or Omai, became the first Tahitian to land in Britain, after sailing back with Captain James Cook from the Pacific Islands. Beloved of the king and queen, Omai (opposite) soon became a celebrity – although he was unfortunately referred to as 'the noble savage' or 'the Indian of the Friendly Isles' – and was painted by Sir Joshua Reynolds, the pre-eminent portraitist of his day. A barefooted Omai appears robed in 'the habit of his country', with a white turban and flowing gown, striking a heroic, haughty pose.

Undoubtedly romanticized, idealized and fraught with exoticized tropical stereotypes, the portrait is nevertheless a sympathetic image, painted full length and near life size to allow a human connection with the subject. Reynolds chose the format to match a commission he made of the Duchess of Devonshire, which was hung side by side with *Omai* at the Royal Academy in 1776. While there was some tradition of portraying South Asian or Indian servants, certainly they were not awarded the same status as images of royalty or aristocracy, as Reynolds did, seemingly without expectation of gaining any particular favour or commercial gain – in fact, the portrait remained in his studio until the artist's death.

A century before this, Diego Velázquez made an even more astonishing portrait of a slave of African descent, Juan de Pareja (ill. p. 68), who was the artist's assistant and would later become a painter of note in his own right. Not only does Pareja defiantly stare back at the viewer in his lordly finery, rather than wistfully glancing into the distance as Omai does in his own portrait, but he also arrogantly declares his own freedom from enslavement, which was effectively handed to him by his master, who signed his emancipation papers in the same year this portrait was painted.

If Velázquez briefly managed to collapse the distance between races and the relationship between slave and master, then an earlier and long-sustained tradition succeeded in both compressing time and suppressing racial differences in such a way as to still seem contemporary, some 2,000 years on. The ancient art of mummy portraiture was practised primarily in the Egyptian oasis known as Fayum, during the period of Roman rule from roughly 30 BC to 700 AD. To accompany a dead body in preparation for its journey into the hereafter, a skilled painter would leave a likeness of the person to be buried, usually painted in a mixture of egg tempera paint and heated beeswax, on a decorative wooden panel affixed to the mummified figure.

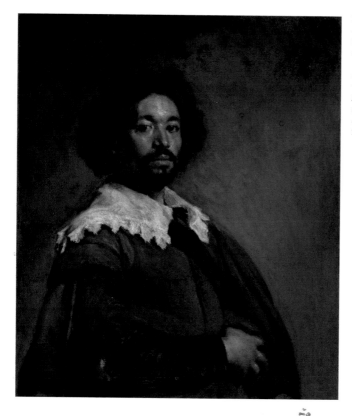

Diego Velázquez, *Juan de Pareja*, 1650. The Metropolitan Museum of Art, New York

Opposite Attributed to the Isidora Master, *Mummy Portrait of a Woman*, AD 100. The J. Paul Getty Museum, Los Angeles

Look Again

Many of these remarkably candid portraits still exist in museums today, but rather than being stiff records of past lives, they each appear as an uncanny window on to a living person and his or her culture, despite the two millennia gap. Seeking this kind of connection with the audience is perhaps the highest calling for an artist – to be able to reveal emotions or expressions that resonate universally or personally is surely more relevant than sheer observational prowess. Just as a great writer can distil the wisdom of an age, so a great painter can conjure the truth from an image or a sitter beyond mere mimesis.

Chapter 3
Art as Drama

All the world's a stage, and all the men and women
merely players. They have their exits and entrances.
William Shakespeare, 1599

The Old Masters were not just philosophers and soothsayers, but also
entertainers, wooing and wowing crowds with ever-larger and more
spectacular compositions. Their canvases became stages on which they
could present their imagined plays, personal psychodramas or tragic
narratives. Not only could these artists move their principal actors
around at will and twist any classic tale to suit their whim, but such
theatrical arrangements also allowed viewers the possibility of getting in
on the action too, joining the painted protagonists under the proscenium
arch. The cinematic scale of the so-called 'salon' paintings – often life
sized and scaled more like murals – were perhaps the 19th-century
equivalents of today's Hollywood blockbuster films or akin to painterly
fireworks displays – clearly designed to pull in the punters or patrons.

John Martin, an Englishman of the Victorian era prone to delusions
of impending apocalypse, was one such painterly pyrotechnician, known
for cataclysmic landscapes lit by lightning and filled with perilous
ravines or visions of Hades, such as the preposterous but compelling
Pandemonium (1841; opposite), which depicts Satan marshalling forth his
underworld armies out of what looks like a lava-filled Thames towards
a smouldering Houses of Parliament. If his works frequently veered from
the fantastical to the frivolous, or from the epic to the bathetic, then their
presentation (beyond the picture frames, which he often designed himself;
in this case, replete with writhing dragons) was also blown out of all
proportions. His paintings went on long, ticketed nationwide and even
international tours, which were conducted in all kinds of venues, from
music halls and theatres to science fairs and shopping centres. The works
were often accompanied by rousing music, booming voice-overs and light

shows provided by moving coloured glass filters, such was the prevailing taste for all things sensationalistic and populist. Martin became a rich and famous man as a result, although he never received praise from his contemporaries and was famously dismissed as a 'painter of pantomimes' by fellow countryman John Constable.

Such melodramatic flourishes were not limited to the unscrupulous, money-grabbing ringmasters of the 19th century, however. Even an unmistakable masterpiece by an undisputed maestro, such as *The Taking of Christ* (1602; ill. p. 72) by Caravaggio, was subjected to the ignominy of being demurely hidden behind a curtain, so that guests to the Palazzo Mattei would be suitably astonished when the drapery was pulled back for the big reveal. Of course, immediacy is one effective delivery system for the provision of sheer drama, and this work might be considered something of a shot in the arm for just such an unsuspecting viewer. Given the extreme concentration of figures, faces, limbs and expressions crammed into this

John Martin, *Pandemonium*, 1841. Louvre, Paris

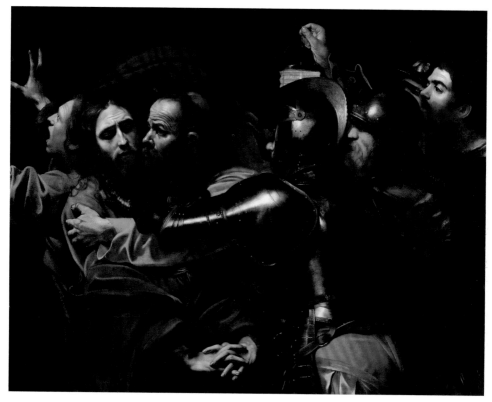

Michelangelo Merisi da Caravaggio, *The Taking of Christ*, 1602.
National Gallery of Ireland, Dublin

Look Again

composition, however, it seems surplus to requirements to further heighten the viewing experience with the theatrical swish of a curtain, when the image itself is already so full of incident and intrigue.

The only relatively calm point in this work is the figure of Jesus, shown seemingly being thrust from a central position in the composition towards the left by an accusatory Judas (having planted his treacherous kiss on the ashen-faced Christ), followed by a pair of lunging soldiers. Arms and heads of different characters are jumbled and fused in an oddly shallow space, flattened further by the nighttime backdrop. The flashes of illumination, typical of Caravaggio's trademark use of contrasting areas of light and dark (known as *chiaroscuro*), are also difficult to make sense of, having no fixed point of origin and certainly not emanating from the lantern being held by a figure on the right, rumoured to be the artist's self-portrait. Whether or not this chaotic, violent scene is also somewhat autobiographical – salacious historians like nothing more than drudging up the artist's criminal records and preponderance for punch-ups – there is no doubting the effect is a powerful jolt to the senses. Caravaggio was the ultimate artist-dramatist, playing to and with his audience, while challenging the sceptical and rousing the sleepy among them.

Although verging on horror – another theme explored in this book (see chapter 5) – the Old Testament story of Judith slaying the general Holofernes while he lay drunk, so that he could not sack her hometown, was a grisly favourite of Caravaggio and his followers, known collectively as the Caravaggisti. Among this generation of artists, supposedly trailing in their master's wake, was Artemisia Gentileschi, whose *Judith Beheading Holofernes* (*c.* 1620; ill. p. 74) was remarkable, not only for being more gruesome than Caravaggio's original version of 1598–99, but also for being painted by a woman.

Like her predecessor, Gentileschi painted herself into the picture, taking the lead role in decapitation duties, as her maid helps to hold the man down. This decision to portray herself centre stage may relate to real-life events, given that her mentor, Agostino Tassi, had been tried and convicted in court for her rape when she was aged just 18 (another work, *Susannah and the Elders* of 1622, plays on the semi-clothed heroine's vulnerability in the face of two lustful onlookers). Her heightened passion and empathy with Judith's vengeance is evident in the blood that spurts theatrically from the man's neck and in the repeated maroon hues of a wine-coloured cloth, criss-crossing the image like so many open veins.

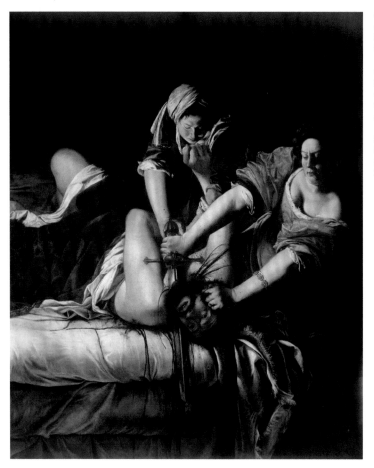

Artemisia Gentileschi,
*Judith Beheading
Holofernes*, c. 1620.
The Uffizi, Florence

Opposite Jusepe de
Ribera, *The Martyrdom
of St Bartholomew*,
1634. National Gallery
of Art, Washington

Overleaf Théodore
Géricault, *The Raft
of the Medusa*, 1819.
Louvre, Paris

As well as imbuing her merciless female figures with a calm certainty,
Gentileschi reverses all received gender roles by flipping the man and
his head upside down and exacting her bloody revenge on the upended
male body of art history.

Such graphic scenarios and over-the-top visions are not the only
elements necessary to add a sense of dramaturgy to a painting. Jusepe
de Ribera, a Spanish painter also influenced by Caravaggio, manages
to hint at the trauma to come in his telling of *The Martyrdom of
St Bartholomew* (1634; opposite) by using the powers of suggestion and

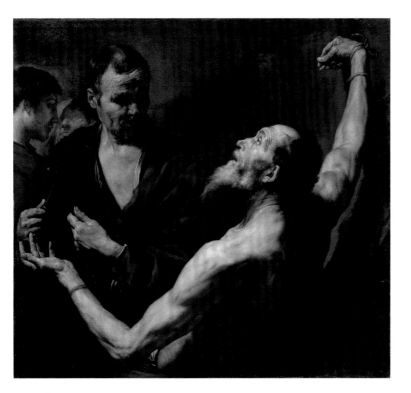

composition, rather than shock and slaughter. An executioner sharpens his knife, while the repentant old man Bartholomew prepares to be flayed alive, offering up his left hand in acceptance of his dreadful fate, causing his would-be assassin a moment's reflection that throws the whole plot into doubt. Not only does Ribera spare us the saint's ghastly destiny, but he also denies us the divine inspiration he has witnessed from above, momentarily stopping us, and his killer, in our tracks.

Perhaps one of the most dramatic narratives ever committed to canvas – although one that sails just as close to revulsion as the previously cited examples – is *The Raft of the Medusa* (1819; overleaf), by Théodore Géricault, based on a book detailing the aftermath of a shipwreck en route to the French colony of Senegal just three years earlier. In Géricault's painting, a treacherous sea threatens to swallow up a brave band of brothers clinging desperately to a rickety craft, inadequate to prevent the

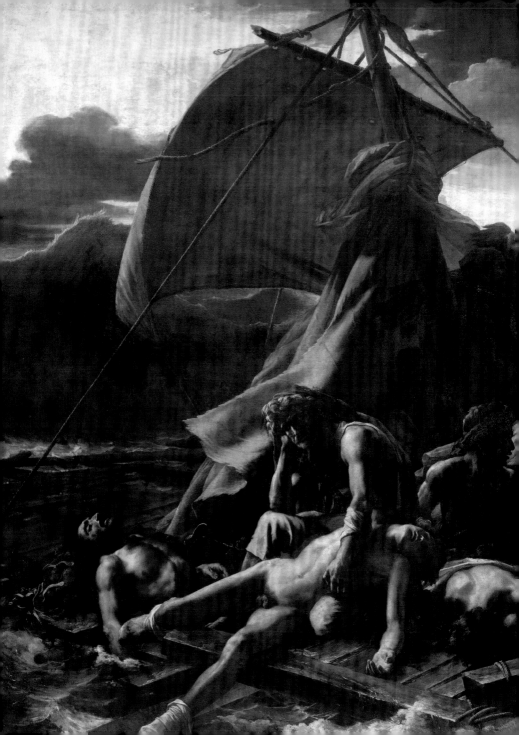

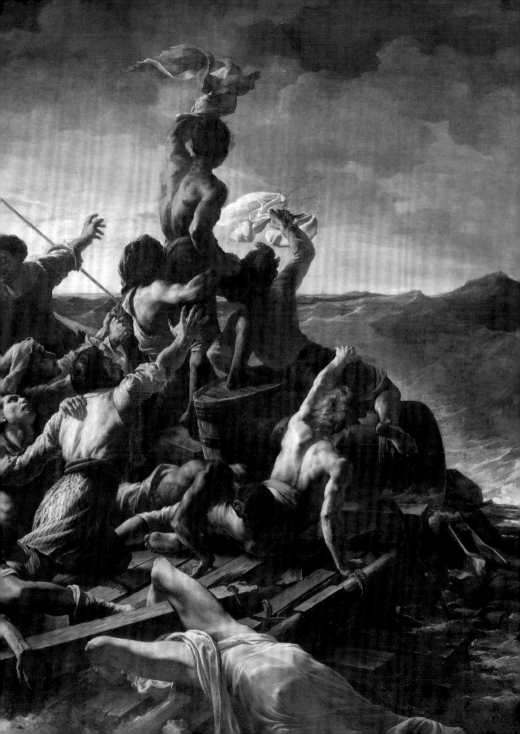

desperate, dying bodies from spilling over the side. In truth, of the 150 souls set adrift, only 15 made it back alive, after unspeakable atrocities that began with mutiny and ended two weeks later with barbarity, suicide, starvation, delirium and even cannibalism.

It is well documented that Géricault went to great lengths to accurately depict the scene, conducting interviews with surviving members of the crew and visiting hospitals and morgues to sketch discoloured, disassociated limbs and the sickly pallor of putrefaction up close, of which various studies survive, such as *Anatomical Pieces* (1818) and *Head of a Guillotined Man* (1819). Yet what he was providing was closer to journalistic reportage than to epic history painting or salacious ambulance chasing, the event depicted being such a contemporaneous occurrence and a topical point of discussion at the time.

The fame of the story was heightened by Géricault's expressiveness and scale – his canvas is not that much smaller than the actual dimensions of the fateful raft – but aside from its anguish and vastness, there was another dramatic tool that provides a further charge to this relentlessly energetic work. If it was the A for Allegory that best summed up the philosophical works seen in chapter 1 and the other A from the R.A.S.A. formula, Atmosphere, for those grouped under the heading of Honesty in the previous chapter, then it is the R for Rhythm that often drives dramatic spectacle in a work such as *The Raft of the Medusa*. Géricault's picture throbs with wave after wave, not just of water, but of humanity aboard the raft, with arms thrusting towards the horizon and limbs and torsos rippling and undulating across the painted surface. The entire surface is roiling, allowing your eye to dart incessantly between details and diagonals, leading you to yet more action, but never allowing you to visually consume the work in one glance.

Another canvas that appears to be in perpetual motion is *Tiger, Lion and Leopard Hunt* (1615–17; opposite) by Peter Paul Rubens. All muscle and dynamism, this convulsive set piece pitting man against beast is built around a central vortex – see the circular shape by following the tiger's arched back and tail all the way round, bisecting the horse's head, to the body of the man being mauled. Outside of this swirling, centrifugal storm are smaller whorls and free-flowing arabesques that occupy almost every inch of the canvas, creating a multitude of focal points and, in turn, the sense of a viciously churning battle in which Rubens is purposefully bringing the fight to us.

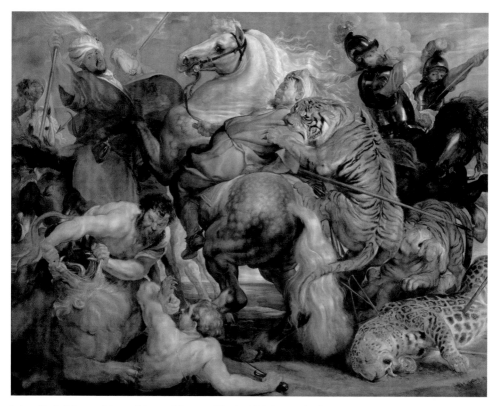

Peter Paul Rubens, *Tiger, Lion and Leopard Hunt*, 1615–17. Musée des Beaux Arts, Rennes

An Jung-sik, *View of Yeonggwang Town*, 1915. Leeum, Samsung Museum of Art, Seoul

 A different kind of audience participation is experienced in front of the kinds of painted screens decorated with panoramic landscapes found in the traditions of Japan, China, Taiwan and Korea. These freestanding objects are composed of multiple panels and were often placed around other furniture or to screen off a portion of an interior for reasons of privacy. The landscapes depicted across the length of these elaborate room dividers are often far more immersive and three-dimensional than most of their Western counterparts, as they allow the observer to wander back and forth, perusing the scene as if one was there. One relatively recent example of this ancient practice, which I encountered in a museum in Seoul, is the 10-panel, 5 m (16½ ft)-wide

View of Yeonggwang Town (1915; above) by An Jung-sik (also known as Simjeon), an artist who bridged the gap between traditional and modern styles of Korean art. While there were elements of the vertiginous mountain ranges seen in Chinese ink paintings on vertical, hanging scrolls from the much earlier Ming dynasty, there was also an illusionistic depth provided by the houses and roads in the foreground, rendered in more familiar linear perspective. The effect was to encourage me to step beyond the picture plane into this alternate world, not because it attempted any photorealistic trickery, but because of the way it was constructed as a stage for walking around and an arena for activating the imagination.

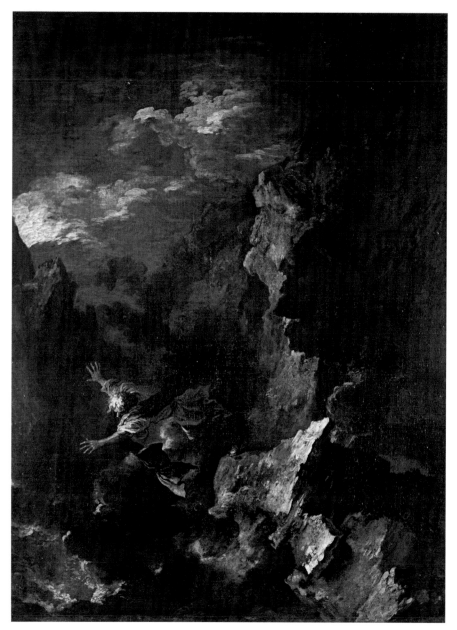

Salvator Rosa, *The Death of Empedocles*, c. 1665–70. Private collection

Look Again

Instead of striving for technical proficiency or truth to nature, all artist-dramatists are in some way engaged in creating proto-performative experiences, closer in kinship to our latter-day installation artists than to classical, two-dimensional picture-makers. One artist known for his live action-packed pictures, as much as his own colourful past, is Salvator Rosa, whose wild way with a brush resulted in such gut-wrenching images as *The Death of Empedocles* (c. 1665–70; opposite), in which a philosopher throws himself into the volcanic mouth of Mount Etna.

The entire landscape seems to be rushing by, the figure's robes billowing in mid-air as the crater threatens to swallow him up. It is both a dive into the great unknown – Empedocles believed himself God-like and wanted to prove himself more than mortal through his leap of faith – and an act of madness, because ultimately the volcano spat out one of his sandals, proving him to be a mere man after all. The artist made sure that we feel unsure: not only about this figure's future, but about the stability of the very ground beneath our feet. The picture presents us with the view over the brink, urging us to give in to our instincts to bow to the forces of nature and let go.

As we began this chapter, so we end, with a grand, over-the-top, am-dram suite of paintings wrought from fire and brimstone. This time it is the American artist, Thomas Cole (although he was born in the north of England and lived there until he was 17), whose five-part series, *The Course of Empire* (1833–36), charts the rise and fall of an entire civilization, beginning with *The Savage State* and *The Arcadian State*, before moving on to *The Consummation of Empire*, *Destruction* (ill. pp. 84, 85) and finally, *Desolation*. Ostensibly this is the tale of man's self-immolating folly, from his innocent time as a hunter-gatherer to that of a simple farmer, before he went on to build great monuments to his own image and wage war on his fellow humans, and then reducing all of this to rubble, only for wilderness to return and bring the world full circle, back to its primitive origins.

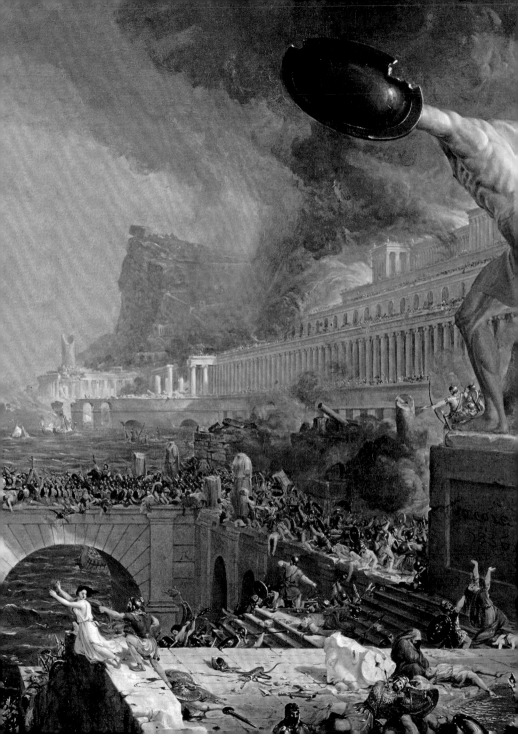

Whatever decadence and decay Cole himself was railing against – perhaps it was partly his adopted country's moral and political decline, as well as the luxuries, excesses and revolutions he had witnessed when travelling in Europe, or Britain's fading influence as an Empire, combined with the encroaching industrialization he had grown up around as a child – these epically doomy paintings could just as well be cautionary eco-tales about 21st-century life and our continued ravaging of the environment. Indeed, these are the perfect images to represent the passing from one geological epoch – the Holocene, or the Age of Man – to the next and perhaps final for all concerned, which is tentatively called the Anthropocene, or the Age of the Manmade. Beware the era after that, when nature inevitably retaliates, warns Cole, as our role in the grand scheme of things may not be quite so central or as long-lasting as we would like to think.

Thomas Cole, *The Course of Empire: Destruction*, 1836.
New-York Historical Society, New York

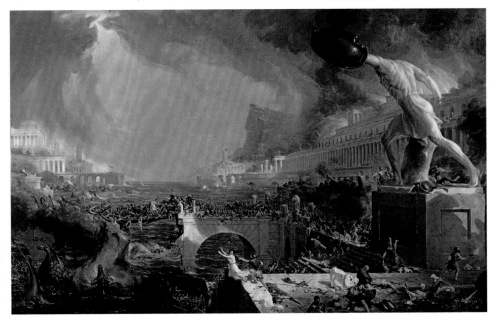

The best painters can weave a narrative or fashion a script as compelling as any author or playwright, holding us in suspense or tricking us with a twist in the tale. One such surprise ending comes in Lucas Cranach's *Fountain of Youth* (1546; below), a terribly modern moral fable, despite its medieval fairy-tale origins. Reading from left to right, we see a group of elderly and frail women being brought towards the mineral pool (see detail, opposite), which some are entering under no little duress and personal stress. Once bathed and immersed in the enchanted waters, these crones are rejuvenated as nymphs, emerging on the other side as nubile maidens once more. In the revelling, dancing and feasting that follows in the top right-hand corner, we understand that it was only the women who required such cosmetic restoration. The men of Cranach's world either are not ashamed of their relative age, are made magically more youthful by their choice of a beautiful younger partner, or else are not hampered in society by their looks in the first instance, which is a story as old as the hills as it is relevant, half a millennium on.

Lucas Cranach, *Fountain of Youth*, 1546. Gemäldegalerie, Berlin

Look Again

Chapter 4
Art as Beauty

Dwell on the beauty of life. Watch the stars, and see yourself running with them. *Marcus Aurelius, 170 AD*

Beauty seems like such an old-fashioned notion that nowadays we almost dare not speak its name. Indeed, Old Masters are so often judged by attractiveness alone that it has nearly become an inane, redundant qualification to make about any work of art. All exquisitely observed, technically proficient pictures might be regarded as beautiful, so that any fictional section of a museum dedicated to 'beauty' might well go on forever, with gallery after gallery filled with a parade of superficially appealing idylls or tastefully composed confections. As the default, lowest-common denominator of a response, the word is little more than something platitudinous to say about a painting. It could also be a pernicious pursuit, one that attempts to hoodwink the audience through falsely flattering portrayals that are opposed to the art of honesty or reality we encountered in a previous chapter. By these vague standards, beauty could be regarded as a generic, dismissive and reductive term, rather than anything beneficial or laudatory to uphold in art.

However, as one of art's great maxims, beauty is so fundamental to art history, humanity and our abiding value systems as to be impervious to the threat of actual extinction, much like the act of painting itself, which has supposedly been killed off numerous times, only to be resurrected with metronomic regularity. If the Old Masters seem to suffer from a surfeit of beauty, there is still an upper echelon of poise, elegance, purity and exquisiteness to be found beyond mere lip-service loveliness. Each age has its own rejuvenated and reinvented form of beauty, one that is more enigmatic, seductive and heady than the last.

What I am proposing to focus on, then, is not a generic, run-of-the-mill idea of beauty, but rather this higher form of elegiac, indescribable subtlety – the superlative notions of perfection and impossible beauty

in art – as well as a more complex kind of unorthodox beauty, one that challenges the norms and reinterprets what we think of as beautiful. Even if we are led to believe that it is a matter of subjective opinion – that beauty is in the eye of the beholder – there are some works that are indisputably, perennially, beautiful. Leonardo da Vinci is renowned, among his many other talents, for capturing something of the essence of feminine beauty in such works as the *Mona Lisa* and *La Belle Ferronière*, as well as the captivating *Lady with an Ermine* (*c.* 1490; ill. p. 89).

These women's expressions are all nuanced and inscrutable, existing somewhere between aloofness, concentration and satisfaction, suggesting simultaneously a coquettish pleasure and a fierce disdain for whoever is in front of them. The strange sight of a weasel (or more correctly, in its white winter coat, a stoat) being caressed by the sitter in *Lady with an Ermine* represents both a painterly visual pun (the Greek word *galée* is close to the surname of the subject, Cecilia Gallerani) and a symbol of purity and moderation. More astonishing even than the creature's lifelikeness is its physical likeness to and bodily reflection of the sitter, through its elegant but muscular, twisting posture.

As Leonardo was such an advocate of the underlying mathematical precision connecting and governing all living things, his artistic beauty could be understood as a mastery of the structural qualities of the physical world, such as the use of the Vitruvian golden section or his own system of *de divina proportione*, as he called it. Yet this would not account for the sensitivity with which he has depicted Cecilia Gallerani in *Lady with an Ermine*. In fact, studies showing that the artist's fingerprints are evident beneath her brow and on the animal's fur would suggest that painting was not a rational pursuit for him, but rather an activity and a subject that he cared deeply enough about to caress and mould with his own hands.

Sandro Botticelli, *Birth of Venus*,
c. 1485. The Uffizi, Florence

On p. 89 Leonardo da Vinci, *Lady with an Ermine*,
c. 1490. Princes Czartoryski Museum, Kraków

At around the same moment in time that Leonardo began painting his portraits of Milanese courtiers, Sandro Botticelli had already produced his own timeless image of female perfection, the *Birth of Venus* (c. 1485; ill. p. 91), in which the statuesque central figure is seemingly carved from the palest, purest marble. The goddess of love materializes naked, afloat on the sea, attempting to conceal her modesty with a few wisps of hair and her graceful fingers. Having sprung from the waves (according to the origin myth) and been sent forth by the figures on the left, who blow her seashell towards the shore, Venus appears beatific and innocent as a newborn.

But the erotic charge of her sensual pose cannot be discounted – there is even a suggestion that she has just been de-robed and revealed, surprising and compelling her into this posture of decorum. Although the model for Botticelli has been identified as a beauty queen and mistress of the patron who commissioned the painting, the artist has not painted anything like a real woman in a real situation. Rather, he has situated his ultimate image of femininity within a dreamscape, in which the idealized and sexualized body of Venus hovers above the water, suggesting an unattainable, otherworldly beauty.

In a similar vein, albeit over 300 years later, Jean-Auguste-Dominique Ingres painted an ethereal, floating figure, known as *The Valpinçon Bather* (1808; opposite) after the collector who acquired the work. Despite her similarly weightless demeanour, the protagonist of this painting is not some chaste Venus, belonging as she does to a harem of *odalisques*, or concubines, painted by Ingres in a series of exotic and erotic scenes set in Turkish baths. Ingres certainly learnt from Botticelli and other painterly forebears, having spent time in Rome himself, later urging his students to pay homage to the same Italian *maestros* hanging at the Louvre, in order to drink in their inspiration. And while the French artist was clearly reviving some classical notions of beauty, he also went beyond anatomical correctness in his pursuit of bodily perfection, especially so for another great bather, *La Grande Odalisque* (1814), whose elongated back suggests she might have two or three more vertebrae than is physically possible. Even his more sedate, seated *Valpinçon Bather* revisits Old Masterly beauty in a surprising and ambiguous way; here, Ingres shields the face of his object of desire, showing only her exposed spine and marble-white sculptural torso.

Jean-Auguste-Dominique Ingres, *The Bather*,
known as *'The Valpinçon Bather'*, 1808. Louvre, Paris

Lawrence Alma-Tadema, *The Roses of Heliogabalus*, 1888.
Collection Juan Antonio Pérez Simón, Mexico

It wasn't long before painterly beauty began to get out of hand, reaching an apotheosis in the work of the Pre-Raphaelites and in the outpouring of the late Victorian artists who took their paradigms of beauty from ancient ideals, as well as medieval examples and myths, but to torrential, terminal extremes – as in the case of Lawrence Alma-Tadema, who depicted a riot of pink petals showering a group of languid revellers at a Roman banquet in *The Roses of Heliogabalus* (1888; above).

Not only will most of today's viewers find it hard to read this narrative, buried as it is beneath the kitsch display of swirling, smothering blooms, but it may well have been lost on the painting's original audience at the Royal Academy; indeed, Alma-Tadema was accused by John Ruskin of being 'the worst painter of the 19th century'. If such an excessive work could be seen as the ultimate metaphor for the much-vaunted end of beauty – suffocated by an overbearing weight of prettiness, ironically of its own making – then it is little surprise that beauty has become such a dirty word in modern and contemporary art.

Perhaps the beginning of beauty's problems date back to its very birth – even if it seems ridiculous that one social-media website recently banned possibly the earliest human representation of the naked female form, the prehistoric Venus of Willendorf (at least 25,000 BC), from being posted to its platform. While it would also be prudish to think of Botticelli's Venus as either pornographic or offensive, his idea of beauty involves an overt objectification of his subject and a covert suggestion of female genitalia in the enclosing seashell. Ingres too infects his enticing and subtly modelled, yet faceless, nude with a dehumanizing gaze. It would seem that all beauty, when applied to the female form, is hopelessly fraught and flawed.

There are moments during the history of art, however, where the fairer sex begins to reassert an influence over how beauty is depicted, if not controlled, given how few female painters (such as Artemisia Gentileschi, discussed in the previous chapter) were ever allowed to fully express their voice or views – ironically, they weren't even permitted to attend the kinds of life-drawing classes that taught the art of nude.

The Italian painter Tiziano Vecelli, better known as Titian, returned over and over to the theme of *Venus with a Mirror*, painting at least 15 different versions. His favourite, or at least the one that stayed in his studio until his death, features a semi-naked beauty in typical coy pose, feigning to cover herself up with a fur-lined drape (ill. p. 96). Yet what we see in the mirror is not this outward appearance, but a glimpse of her face in a state of wide-eyed terror, either signifying a look of startled fear or shooting back an accusatory glare at the viewer. This act of staring out of the picture suggests that not only can she see us, perhaps covering her exposed self in the process of realization, but that she is also challenging the viewer's voyeurism and is either horrified or affronted by our presence. The glance of unease on the face of her mirrored self is perhaps a view into the future and an admission that beauty can be scrutinized and questioned at every turn, being only a transient quality that fades and eventually disappears with age.

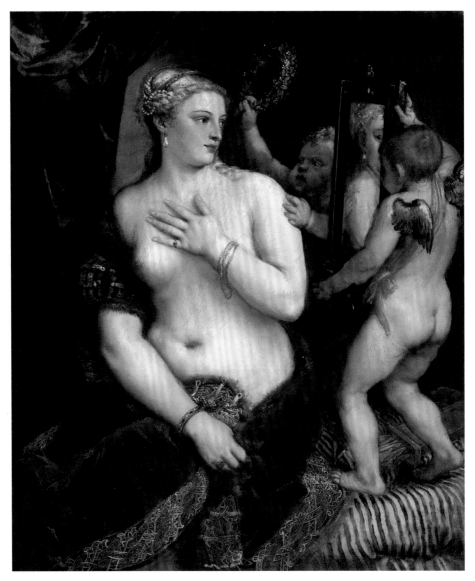

Titian, *Venus with a Mirror*, c. 1555. National Gallery of Art, Washington

Look Again

When regarded as something precious, complex or fragile, rather than merely an opportunity to ogle or enjoy, beauty in art takes on a depth of character and awakens in the viewer the possibility of perceiving or recognizing wonders that are not readily visible, but are instead somehow concealed within the paint. Discovering beauty then becomes a matter not only of personal taste in the beholder, but also of flexing our individual powers of discernment and bridging that gap in centuries between what was painted then and what we understand of it now. Of course, these days codes of beauty change faster than ever before, as the fickle hand of fashion and the impermanence of the digital image reinvent society's tastes and aesthetic norms constantly. But before such a comprehensive fracturing of beauty, comes the celebration of alternative beauty and difference.

Peter Paul Rubens, *Nymphs and Satyrs*, 1638–40. Museo del Prado, Madrid

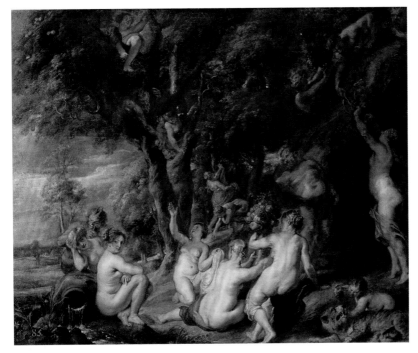

A cursory glance through art history might reveal the standard definition of female attractiveness to revolve around blond hair, fair skin and a svelte figure. Rubens was famous for bucking this trend with his buxom and curvaceous models – giving us the term 'Rubenesque' – but his reappraisal of beauty went further than mere matters of size. True, his figures were of a shape and fleshiness not readily associated with classical ideals of beauty, yet Rubens also imbued his corporeality with intellect and power. In a typically bacchanalian scene, *Nymphs and Satyrs* (1638– 40; ill. p. 97 and below), a bevy of alluring nudes frolic with and beckon to the half-human fauns and the god of lasciviousness and drunkenness himself, Pan. The presence of only make-believe, mythical creatures

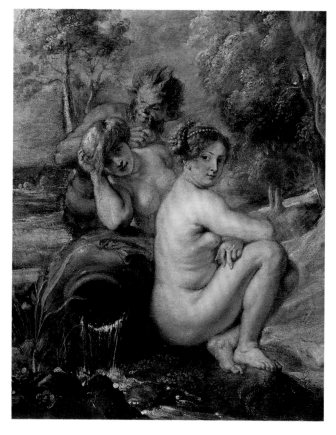

Peter Paul Rubens,
Nymphs and Satyrs (detail)

Look Again

surrounding the sexually enticing women below suggests that their radiant beauty is inaccessible for mere mortals and that true paradise need not involve men at all, as Mother Nature provides happiness and harmony for everyone. Indeed, in other images, Rubens depicted the love and civility of Venus under threat from the corrupting influence and violent upheaval of warring Mars, seemingly promoting the beguiling natural qualities of feminine power over brute masculine force.

Another example of an unconventional beauty surviving and confounding the ages is *The Milkmaid* (*c.* 1660; ill. p. 100) by Johannes Vermeer. Often praised for her wholesome heroicism and saintly dignity – dutifully preparing a repast of bread and milk for her master – she arguably represents more than mere moral servitude. The bawdy reputation of milkmaids was a well-trodden comedic device for earlier Dutch artists, so Vermeer's reserved atmosphere may well be loaded with none-too-subtle inflections and in-jokes, from the wide-open mouth of the jug and its mysterious depths, to the focused maiden's private thoughts, perhaps of amorous encounters (as suggested by a tiny Cupid hidden in one of the Delft tiles near the floor). Without the overt erotic charge of nudity, Vermeer nonetheless imbues his scene with an air of voyeurism, as though we had stumbled on this comely, ample-bosomed figure in the Rubenesque tradition without her knowledge. Despite these suggestive traits, we are left guessing, intrigued but ultimately denied full knowledge as to the milkmaid's true virtues or vices.

From classical and otherworldly beauty, to unexpected and ambiguous beauty, and finally to the redemption or inversion of beauty, the term itself should not be used solely in conjunction with the female form. But even Michelangelo's giant statement of masculinity, the marble statue of *David* (1501–4) with his chiselled torso, provides only further proof of the male-dominated language that surrounds Old Masterly notions of beauty. Further to a sexualized or gender-specific appreciation of beauty, there is inherent in any act of making a struggle to achieve art for art's sake or beauty for beauty's sake. Perhaps because of his ordainment as a Dominican monk, Fra Angelico was fated to a life spent striving for spiritual enlightenment through paint, having been entrusted by his brothers with various commissions for altarpieces and panels in convents and chapels alike. Even those viewers not swayed by anything remotely approaching a religious response to his work cannot but admire Fra Angelico's various versions of the Annunciation (painted from the

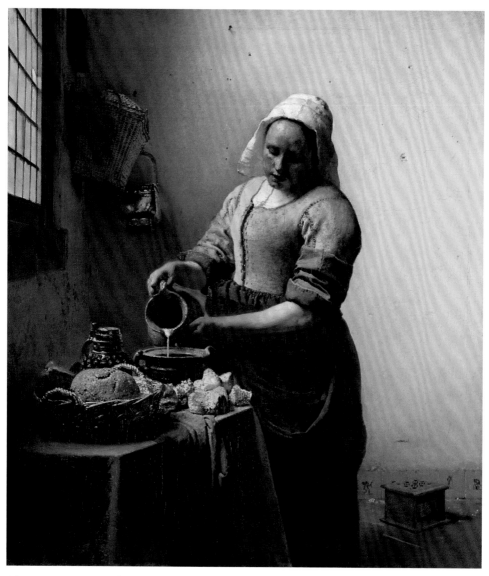

Johannes Vermeer, *The Milkmaid*,
c. 1660. Rijksmuseum, Amsterdam

Overleaf Fra Angelico, *Annunciation*,
c. 1438–45. Monastery of San Marco, Florence

Look Again

1420s to the 1450s), in which the Virgin Mary receives news of her impending pregnancy from the archangel Gabriel in a cloister adjacent to a garden, with light spilling in through the arcade and glinting off the bowing angel's wings. Whether in the homelier frescoed version attached to a wall in Florence (1438–45; overleaf), or in the heavenly version hanging in the Prado Museum in Madrid (1425–26), Fra Angelico captures the moment the information is imparted, leaving the future Mother of God stunned into a contemplative trance, bestowing a calming stillness over the entire scene.

These works were some of the first to go beyond flat, symbolic treatment of the gospel and instil this holiest of moments with humanity, reality and a natural setting. One need not be a believer to understand the potency of Fra Angelico's golden icons and their radiant but serene beauty. Here, the rigid, architectural structure and the introduction of perspective are important framing devices for holding the picture together, but as we saw in the work of Leonardo, beauty tends not to be a conspicuously controlled construction, but an emotional or irrational pull.

If the ancients thought beauty could be found in a perfect proportion, while Renaissance artists found it in the human form and the first flush of Modern artists believed it should be convulsive and abstract, it is clear that there is no single lens through which to properly appreciate it. Indeed, it cannot be easily distilled through the T.A.B.U.L.A. lens, whether that be via time or background (or any of the other steps) or through the rhythm, allegory, structure or atmosphere of the R.A.S.A. method. Perhaps it can only be understood through a combination of all of the above and through one painting's difference from other works, rather than any similarities with what has come before. After all, the most transcendental experiences of beauty in art tend to be those when the observer is struck by a painting that almost blinds with its beauty, one that glows from within and seemingly blots out everything else in the room.

ɾinimtis nobile ɾriolinum

ȢVRAM DRETEREVNDO CAVE NE SILEATVR AVE

Chapter 5
Art as Horror

There are moments when even to the sober eye of Reason, the
world of our sad Humanity may assume the semblance of a Hell.
Edgar Allan Poe, 1844

As we have just seen, a common conception of art's true purpose revolves
around its ability to portray beauty, or else to lift the spirits, exalt
the holy or pay homage to kings. Yet many artists have long harnessed
the power of images to shock, frighten, forewarn or fantasize. While
some Old Masters could be bloodthirsty and provocative for the sake
of grabbing an audience or gaining notoriety, other artists depicted horror
as a means to probe the deepest and darkest corners of our collective
psyche. There were those who went to the lengths of frequenting mental
asylums or sketching decaying or decapitated bodies at the morgue
in order to depict disease or death first hand. And, depending on which
historical accounts you read or believe, there have been painters who
themselves resorted to violence or harboured disturbing experiences,
as further grist to their dark, artistic mills.

There can be few more gruesome sights than that of the central
panel of the seven that make up *The Isenheim Altarpiece* (ill. opposite,
above), painted by Matthias Grünewald (properly known by the name
Mathis Gothart Neithardt) in 1512–16. Jesus is shown brutally nailed to
a rudimentary cross, poorly fashioned from two roughly stripped beams
of wood, the horizontal support bowing and bending under the tragic
weight of its load. Neither is Jesus glorified in any way: his loincloth is
a rag; his hands, fingers, feet and toes are mangled and contorted through
sheer pain; and the sharp thorns seem to have dispersed from his crown
and embedded themselves into his flesh, which has turned a nightmarish,
gangrenous shade of yellow-green (see detail opposite, below).

Although painted on the cusp of the Reformation and so at the
juncture between the end of the medieval period, Germanic Gothic

Matthias Grünewald,
The Isenheim Altarpiece,
1512–16. Unterlinden
Museum, Colmar

and the first flush of the new Northern Renaissance, this is one of the few occasions in art history when the Crucifixion is painted in such a startlingly realistic and almost non-religious manner. Not only is the modelling accurate as a description of a figure ravaged by the final throes of painful death, but we also see, perhaps for the first time, the Son of God in a state beyond this mortal coil (but pre-Holy Spirit). His body is a mere shell, drained of any semblance of life, with his arms almost wrenched from their sockets as a result of his torturous, lifeless position. The visceral sense of an arm being ripped from its body is exacerbated further by a vertical cut in the limewood panel, where it can be opened up to reveal Christ's eventual resurrection, among other leaves in this polyptych including the Annunciation, Nativity, Lamentation and the Deposition from the Cross.

While these latter scenes provide a glimmer of hope for those able to experience the rest of Christ's arc beyond the initial affright of the Crucifixion (although Grünewald's folding masterpiece was traditionally opened up only on certain special days every year), Hans Holbein's *The Dead Christ in the Tomb* (1521–22; below) has no such redeeming features or supplementary context. Arguably there are signs of stirring in the half-closed eyes of this corpse, and it could be that this strange work was commissioned as part of a multi-panel altarpiece, providing a similar function to the lower section of Grünewald's composition. However, without any certainty around the origin or possible destination of this painting, all we are left with is an emaciated Jesus, left prone on a simple, sheet-covered funeral slab.

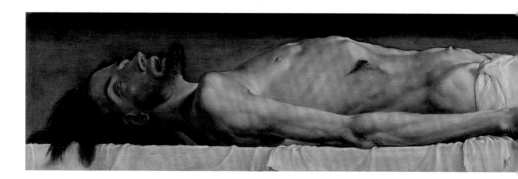

Look Again

Holbein's unflinching naturalism hones in on the decay and putrefaction overtaking the body of Christ – his pallid appearance is closer to that of a skeletal spectre than heroic life-giver or miracle worker (it was rumoured the artist used a dead body fished out of the Rhine as his model). Yet the true horror of *The Dead Christ in the Tomb* is not that most people have never seen a cadaver up close, because nowadays we see images of death and destruction shared almost instantaneously on the Internet and we rarely notice their awfulness. Instead, it is the unnatural, constrictive space in which the figure is trapped, as though we were looking at a cross section of his coffin or crypt (indeed, this recalls a recent x-ray image that went viral, in which a child refugee could be seen being smuggled across the Spanish border, cruelly balled up inside a suitcase).

Something similar, albeit less extreme, occurs in Andrea Mantegna's earlier *The Dead Christ and Three Mourners* (1470–74; ill. p. 108), which skews the view of Christ as though we were one of the mourners, kneeling at his wounded, cracked feet. The sense of being in the same room or sharing the sepulchral space with his cold, deceased body makes both of these works as close to truly terrifying museum experiences as one can get. Furthermore, the human scale and trompe-l'oeil details of both paintings – especially the protruding feet in Mantegna's version, or the pointing finger and tumbling lock of hair encroaching towards the viewer in Holbein's picture – heighten the claustrophobic finality of entombment, also raising the possibility that Jesus might never rise again after such an ignominious, irrevocable end.

Hans Holbein, *The Dead Christ in the Tomb*, 1521–22. Kunstmuseum Basel

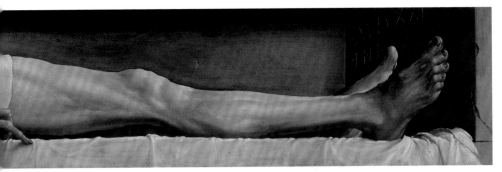

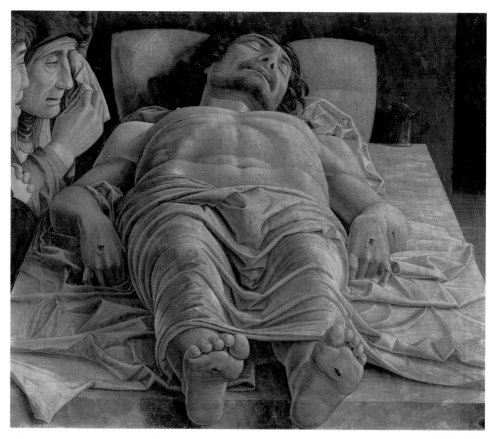

Andrea Mantegna, *The Dead Christ and Three Mourners*, 1470–74. Pinacoteca di Brera, Milan

Overleaf Francisco de Goya, *The Third of May 1808*, 1814. Museo del Prado, Madrid

Look Again

As unsettling as it is to encounter early Old Master imagery calling time on the Christian doctrine of salvation, it is similarly jarring to find an updated version of the Crucifixion narrative, such as Francisco de Goya's *The Third of May 1808* (1814; overleaf), in a wholly secular setting. The horrified man in white with outstretched arms who would be Jesus in this nighttime scene (he also has the subtle suggestion of stigmata lesions on his open palms) is actually a nameless protestor, perhaps a rebel or simply an ordinary Spanish citizen, being lined up for execution by the French firing squad, who are illuminated by the central lamp but also anonymous, no more than mechanical pawns of impending doom. The realization here is that war produces no valiant victor nor martyred freedom fighter, only the squalid churn of statistical deaths witnessed by the pile of bodies in the foreground and the inevitability of further suffering to come. While religious feeling and fervour comes and goes, war never ends.

The history of painting is littered with epic battles between heaven and hell or good and evil, usually being played out by angelic warriors swooping down from above against an army of inhuman creatures who inhabit the world below. Even Goya's genre-defying work has a traditionally bellicose pendant picture, entitled *The Second of May 1808* (also painted in 1814), which shows a more typical telling of the tragic Dos de Mayo Uprising, featuring a cavalry charge against the rebellious Madrid mob and much knife-wielding and general blood-letting. These combative set pieces provide the classic axis for moral instruction, while also providing some comparative shade in opposition to the relentless light and lecturing of religious instructional painting. Goya's rendering of the French retaliation on the day after, however, muddies the age-old dichotomy of good triumphing over bad, because there is no happy ending, no miraculously unlikely U-turn on the battlefield and no saviour to savour for posterity.

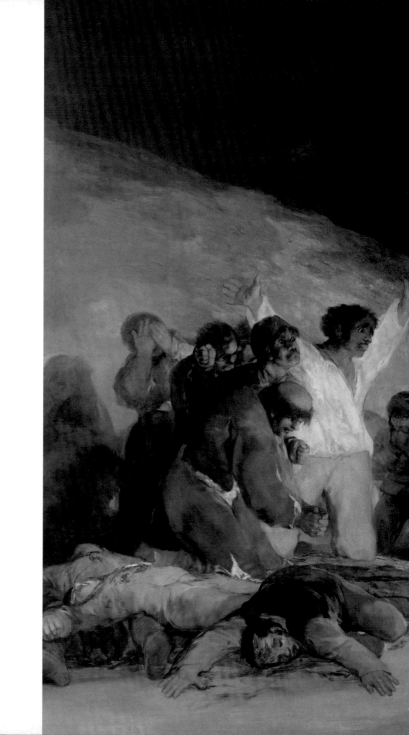

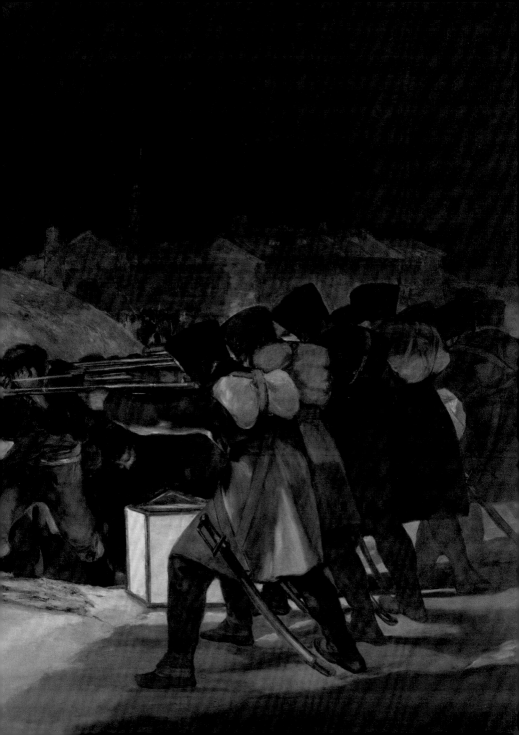

Still, every Old Master is more complex and nuanced than it first appears, no matter the shocking evidence of brutality on display. Goya, for example, was partially atoning for his sins as a well-paid painter working under commission for the French court pre-invasion, and only belatedly siding, if never physically joining in arms, with his Spanish compatriots. On the other side of the propaganda war were proud Gallic artists such as Jacques-Louis David – whose *Death of Marat* (ill. p. 19) exemplified the need to know an artist's political leanings in the Background section of the T.A.B.U.L.A. formula – and Antoine-Jean Gros, whose own agitprop contributions to the Napoleonic war effort included the monumental *Bonaparte Visiting the Victims of the Plague at Jaffa* (1804; opposite).

In Gros's painting, we see former soldiers of the French campaign in Egypt and Syria afflicted with bubonic plague in unnerving life size, being approached by their brave general Napoleon (who appears on their level, despite being a famously short man), extending to touch – as if to heal – an open sore on one of the sick, to the disgust of his officers. While the rabble approaching the conquering hero like moths to a flame are clearly in dire straits – their bodies resigned or defeated and their heads in hands – Napoleon's gesture is no salve to their ailments, and a puff of smoke in the background reveals that the fight still rages on, regardless of their plight. As we know, these paintings are more complicated than we can grasp in one glance, so it is only with some extra knowledge (more of that B for Background) that we discover that Gros painted this in the year of Napoleon's coronation as Emperor and that the work was produced almost as a counter-rumour or to somehow prove, after the fact, that the great general did not abandon these troops to the fatal disease or sanction the administration of lethal doses of opium in lieu of bringing them home to France. Horror begets more horror, it would seem.

In 1835 Gros committed suicide, his body discovered floating in the Seine. And while it would again be too crude to believe this was a consequence of anything he had seen or painted, it is worth wondering how Goya dealt with his inner demons and not dissimilar regrets as an artist. The simple answer being, of course, by painting them or, increasingly, by drawing them, as his various suites of etchings, including *The Disasters of War* and the equally disturbing *Caprichos*, attest. In these invariably small ink sketches, Goya could fully express his disgust for war without censorship – picturing unadulterated episodes

Antoine-Jean Gros,
*Bonaparte Visiting the
Victims of the Plague
at Jaffa, March 11, 1799*,
1804. Louvre, Paris

On p. 114 Francisco de
Goya, *Saturn Devouring
his Son*, 1820–23. Museo
del Prado, Madrid

of rape, murder and mutilation – and release all manner of monstrous characters and subconscious imaginings, from giants and witches to devils and donkey-headed humans. While plumbing the darkest depths of men's souls, Goya also gave political, moral and social comment to each drawing through his blunt but revelatory captions, announcing that 'Truth has died', 'Bury them and keep quiet' or 'It is better to die'.

Before Goya, flights of supernatural fancy or superstitions around ghosts, ghouls and gargoyles were not habitual subjects for oil paintings, and were more likely to be seen as figures of fun or scorned as absurd nonsense. Although more than a mere master of horror – being also a great painter of portraits, women, festivities, Spanish life and society – it will be always be the brutal, final suite of 'Black Paintings' for which he will be most vividly remembered. These 14 ghastly nightmares, painted directly onto the walls of his house as he became increasingly old and deaf, featured, among other apparitions, a drowning dog, he-goats, devil worshippers, floating demons, giants fighting with clubs and, most hauntingly, the vision of an ogre chewing the head off a bloodied body, now known as *Saturn Devouring his Son* (1820–23; ill. p. 114). While this certainly was an allegory about Spain's cannibalization of its own citizenry through civil war, it is also a stark reminder of Goya's impending

demise, the savage beast's crazed eyes reflecting the internal wrangling of a mind fearing the abyss – representing the inevitable, unstoppable ingestion of time. After Goya, such trips into the unconscious became more frequent, with artists increasingly plumbing the internal and irrational workings of the mind (more of which we will see in the final chapter about artistic visionaries), although none would surpass the intensity of feeling found in the Black Paintings. Yet Goya was not the first to seek out such gutsy and gruesome topics to paint, nor indeed was he unique in mining the unseen or imagined, where our own mental images are required to finish the pictures on the wall, just as some horror movies use suspense and the threat of off-screen violence to conjure up what only our minds can complete.

At the very dawn of the Italian Renaissance, among the frescoed murals by Masolino and Masaccio in the Brancacci Chapel in Santa Maria del Carmine, Florence, was a painting by the latter artist that might be described as the inverse of the passages of beauty found in Fra Angelico's *Annunciation* (ill. pp. 102–3), located nearby in the Convent of San Marco. *Adam and Eve Banished from Paradise* (c. 1427; ill. p. 116) is a raw and tortured portrayal of the Fall of Man, in which Eve was tempted into plucking the forbidden fruit, only for that first taste to result in the discovery of shame through the sudden cognizance of each other's nakedness. The pain written on Eve's face, echoing through her twisted body, portrays an emotional turmoil that didn't previously exist in the art of the Middle Ages, which were better known for graphic, flat depictions of people who were very rarely nude. Masaccio's figures stride out from the narrow gateway into the unnaturally confined vertical space of the blank, desert landscape before them, having been ousted by the angel of justice and a few disapproving rays of darkness.

Another tough couple to look at is *Death and the Woman* (c. 1520; ill. p. 117) by Hans Baldung Grien, in which the Grim Reaper himself accosts an Eve-like figure in a state of undress, who seems surprised and in the act of turning towards her assailant. Death's leathery, yellowed skin and greying hair contrast with the milky white skin and tumbling tresses of his victim, whose flesh he is gripping while he shifts his repulsive mouth from a kiss of death to a more grisly bite. Ugliness can also be compelling, if rarely comfortable, viewing, and it is only through sheer repugnance that the full force of our mortality and Baldung's message comes to the fore.

Masaccio, *Adam and Eve Banished from Paradise*, c. 1427. Santa Maria del Carmine, Florence

Opposite Hans Baldung Grien, *Death and the Woman*, c. 1520. Kunstmuseum Basel

Look Again

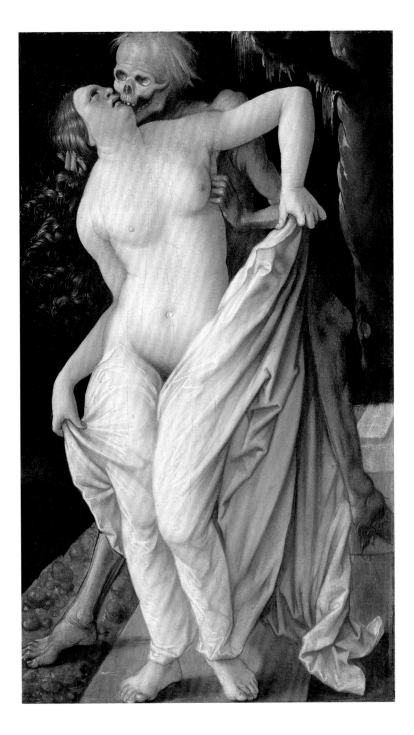

It can be hard to analyse pure horror where there is no light, but the best Old Masters could simultaneously turn stomachs and heads, resulting in a compelling awfulness – or perhaps a beautiful horror – which attracts even as it repels. Titian's wild *Apollo and Marsyas* (1550–76; opposite) is a particularly gory retelling of the vicious myth in which Apollo skins a satyr who loses a musical contest with the bloodthirsty god, ripping off the half-man, half-goat's flesh and nailing it to a tree. Titian paints the scene as furiously as a knife-wielder, employing a pulsating, dizzying array of marks (this constitutes the work's rhythm, also seen in the similarly active arms of each character in the picture). And while there are delightful and spirited passages amid this maelstrom – featuring the fronds of an autumnal forest and an energetic violin player – the violently splayed and inverted central figure is being flayed alive, while his pooling blood is lapped up by a tiny dog.

From Grünewald's *Isenheim Altarpiece* (ill. p. 105) to this painting, cruelty seemingly knows no bounds and transcends time. Whatever one believes to be the foulest degradation for a human being to endure is always surpassed by subsequent generations. While specific threats and menaces have changed – plague, famine and war have been usurped by terrorism, pornographic depravity and ecological disaster – the pull of horror can still exert its skeletal grip across the centuries, shaking us out of our slumber and making us face our demons. No pain, no gain, as you might say in very different circumstances.

Look Again

Titian, *Apollo and Marsyas*, 1550–76. Archdiocesan Museum Kroměříž, Olomouc

Chapter 6
Art as Paradox

Do I contradict myself? Very well then, I contradict myself
(I am large, I contain multitudes). *Walt Whitman, 1855*

Truth, beauty, horror and fantasy ... so far it would seem the Old Master
painters were set on many familiar paths, all striving for the highest
accolades in their chosen discipline – the most realistic, the most dramatic,
and so on. But what of the artists who left behind head-scratching puzzles
that even now refuse easy decipherment? Instead of simple, open books,
their paintings remain complex, codified expressions of conflicting ideas
and mysterious, multi-faceted game-changers.

Even more so than those philosopher-painters in the first chapter,
intent on rivalling history's major thinkers or great works of literature
through their art, the paradoxical painters and sculptors went beyond
provoking mere thought – instead changing perceptions or altering
reality to such an extent that their works cannot be easily unpicked today.
We might associate this kind of genre-defying practice with conceptual
or contemporary art made since 1960, but many artists of the past were
just as calculating, conniving and confounding in their methods and
working processes. It has also been widely and falsely assumed that,
before the arrival of modern art and the 20th century, artists weren't self-
consciously engaged with the process of art-making or effectively able
to critique the fundamental ideas underpinning their creative pursuits.

We have already encountered Vermeer, through his mastery of
storytelling (under A for Association) and his tender depiction of inner
strength and sensuality (in the chapter on beauty), yet for *The Art
of Painting* (c. 1666–68; opposite), the Dutchman envisioned a work
dissecting his own profession into its constituent parts, only to reveal it
anew. The symbols are harder to read nowadays – his model is dressed
as Clio, the personification of history, and holding a trumpet, signifying
the vagaries of fame – but the underlying wisdom is undeniable: here is

Look Again

Johannes Vermeer, *The Art of Painting*, c. 1666–68. Kunsthistorisches Museum, Vienna

a painter caught in the act of painting, attempting to elevate his art form to a noble and life-affirming one that will transcend time and the arc of human narrative. Perhaps these are bold claims to make, but Vermeer seems to stake all of his skills as an artist in order to address future generations about the importance of this work. Indeed, far from testing its powers on his peers and the audiences of his day, Vermeer kept *The Art of Painting* in his possession until he died, prompting speculation as to what he saw or hoped to see in his own handiwork after all those years. Maybe he unwittingly revealed too much by placing himself – or an avatar of himself – front and centre of the picture, as we watch over his back, peering both into the canvas and behind the studio curtain into

the secretive process that could magically transport his ambitions to any beholder, no matter the geographical or temporal setting in which the painting would come to find itself in the intervening years.

Any work of art that somehow refuses to reveal its true purpose or questions its own existence can take on an identity and an air of rumour beyond the facts of its contents or its creation story. Just as Vermeer arguably distilled the ambitions of his life's work into one painting, it is possible to read the same ceaseless wonder at the ability to make line and colour coalesce into pictures in some of the earliest forms of mark making known to man.

To find the cave paintings at Pech Merle, itself located in a remote and rural part of southwestern France, there is a steep descent down a stepped tunnel, although this has long ago been widened since a pair of curious shepherd boys first ventured below ground a century ago. They made the remarkable discovery of a frieze of prehistoric paintings, which are still well preserved and open to the public. A group of majestic animals outlined in black and russet-red pigment – including woolly mammoths, spotted horses and striped reindeer – go striding across the chamber walls in a procession that suggests a reverence and respect for nature that dates back as far as the last Ice Age (around 20,000 BC).

And yet, alongside these creatures are the strange signatures of their creators, in the form of reverse palm prints created by blowing or spitting powdered colour against the backs of the very hands used to fashion the mural. Such shockingly lifelike interventions appear almost photographic in comparison with the mannered and ritualistic depictions of the animals, with their small heads and large bodies – presumably reflecting beliefs around the subservience of beasts of lesser intelligence and their worth as life-giving sustenance for the people of the time. While not recognizably autographed in the manner of a Vermeer, the disembodied hands of these unknown artists return us to the never-ending loop of watching an artist in the moment of making, connecting us forever with an image that seems impossibly distant and alien.

Often there is no fathoming the impetus behind certain decisions that artists have made owing to the dense mists of time, but sometimes it is the strangeness and resulting tension in such works that can speak to the contemporary viewer, much more so than the period's subject matter or dress codes. Perhaps a painter included subconscious messages or somehow undid his own work with a detail that was out

of character or kilter with the norm. Sometimes portraits made for patrons, unbeknownst to them, might have actually meant to mock them. The example often cited in this regard is Goya's group portrayal of *The Family of Carlos IV* (1800; below), with the somewhat oddball gathering of Spanish royals all looking in different directions – one figure's face is entirely hidden from view, while others appear blemished, simple-minded, or staring blankly into the distance (Goya himself lurks in the shadows far left). While unflattering at times and undoubtedly an unconventional composition for depicting the ruling class, Goya's ragtag bunch was nonetheless accurate in its depiction of a slightly ineffectual king and the comparatively dominant queen in the middle.

Where some have seen character assassination, other art historians note the relatively favourable light in which some of the characters are presented – the women at far left and right were in fact suffering from more debilitating afflictions in real life, for example. It was clear that this awkward picture – seemingly see-sawing between satire and truthfulness – was also paying homage to one of the greatest mysteries ever committed

Francisco de Goya, *The Family of Carlos IV*, 1800. Museo del Prado, Madrid

Diego Velázquez, *Las Meninas*, 1656.
Museo del Prado, Madrid

On p. 127 Caspar David Friedrich, *Wanderer Above the Sea of Fog*, c. 1817. Kunsthalle Hamburg

Look Again

to canvas, *Las Meninas* (1656; opposite), painted by Diego Velázquez almost 150 years earlier, a picture so famous that the Spanish royalty would have been only too keen to emulate its greatness through their stilted poses. Even more so than Goya's troublesome tribute, this earlier image of a royal family by Velázquez mimics no historical precedent, nor fits any received genre, being neither a straight portrait nor the record of any momentous moment.

Indeed, the surroundings are hardly palatial, the scene being clearly set in a makeshift studio without any regal pomp or decoration, but the enormity of the space is evident in the far, shadowy reaches of the room and in the convincing depth that leads the eye past the main protagonists arranged at the front. These are the maids-of-honour of the title, surrounding their charge, a pampered young princess in her full finery. Yet these ladies-in-waiting, which include a dwarf and two attendants, seem to be caught off guard, mid-rehearsal, at the point just before putting on their best smiles for the portraitist (the court jester is disobediently kicking a sleeping dog). Except that the artist, the dashing Velázquez himself brandishing a brush and palette, is most likely not painting them at all, but working on a vast full-length image, presumably of the king and queen who appear in a mirror, but are so diminished in size as to seem insignificant to proceedings here.

At this point it might be logical to assume this entire work to be a barely concealed stab at the royal edifice, reducing the heads of state to a floating apparition. However, there are more elements at play here: an off-stage appearance of a nobleman in silhouette entering or exiting by the back door, and another strange half-portrait of a barely recognizable figure to the far right. Amid all this ambiguity – between darkness and light, reality and unreality, self-portraiture and public portraiture – the real swagger and power seem to rest with the painter himself, emblazoned with a cross on his chest, signifying his royal favour and impending knighthood. Yet he seems to be painting for a higher cause, and is answerable only to God, not to the mere mortals scuttling around or even to the king and queen trapped in their fading mirror. Instead, he – Velázquez, I, *yo*, literally the big man in the picture – presides over the entire scenario, plotting out the grander scheme and controlling everything in his purview. Like Vermeer's almost contemporaneous statement about his calling, this too is a painting about painting and ultimately a grand showcase for the artist's painterly talent.

In times of oppression or political upheaval artists might necessarily load paintings with hidden meanings to escape censorship, but what possesses an artist to layer a picture with esoteric, even personal symbolism, seemingly created for an audience of one? Caspar David Friedrich, the preeminent painter of the German Romantic period, specialized in solitary figures gazing in awe at the majesty of nature, and transformed humble landscapes into manifestations of an ethereal sublime. Towering above them all is *Wanderer Above the Sea of Fog* (*c.* 1817; opposite), a gentleman seen from behind as he contemplates a numinous cloudscape on a mountaintop. The paradox of this traveller's position is that his achievement at reaching the summit with just a walking stick to aid him is no more than a mirage – this is an impossible image, formed of the mind, not through the travails of the body.

The boundless expanse of fog punctuated by indistinct, rocky crags means we cannot be certain of what we are looking at, or indeed where we are in relation to the intrepid wanderer, given that our viewpoint hovers seemingly in mid-air, a few feet above and behind. The adventurer's own vista is exactly aligned with the largely indefinable horizon, giving the impression that he is looking into the future or, conversely, inwards to his own life and experience. The idea that this epic impression of the great outdoors might actually be a mental image or the representation of mere intellectual whim is this picture's quandary. It is at once a portrait of the power of the mind for creation and also of our comparative insignificance and possibly futile existence in the face of such overwhelming physical obstacles and psychological uncertainty.

Paintings of the past that refute direct interpretation or reject straightforward categorization make for harder but generally more rewarding viewing experiences, forcing us into dialogue with the artist's often changeable expressions and contradictory statements, which can all be found fighting it out across a single picture. Gustave Courbet's *The Artist's Studio* (1854–55; overleaf) aims to reach the dizzy heights of his forebears Velázquez and Vermeer in making a picture that deals with its own artifice and the artist's mastery over the medium, but is so self-consciously aware of this attempt to create a masterpiece that it flirts with an impossibly encyclopaedic array of themes and unresolvable elements. From left to right, Courbet depicts the world outside – from poor beggars and rich merchants to different religions and the destitute masses on the street – then himself toiling at a canvas, flanked by a nude

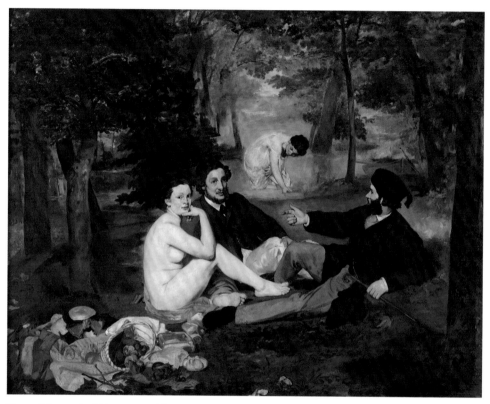

Edouard Manet, *Le Déjeuner sur l'herbe*,
1863. Musée d'Orsay, Paris

Previous pages Gustave Courbet, *The Artist's
Studio*, c. 1854–55. Musée d'Orsay, Paris

Look Again

model and numerous onlookers, and finally his wider circle of friends, contemporaries and supporters from French society, including Charles Baudelaire and Pierre-Paul Prud'hon. Placing himself as the focal point of this complex gathering would suggest that Courbet himself was the link between these disparate social and cultural spheres of life, yet there is no overarching consistency to the jumble of characters, which he called, in the painting's subtitle, 'a real allegory summing up seven years of my artistic and moral life'. Jarringly, Courbet's attention is being swallowed up by the landscape into which the painter himself is almost disappearing; the canvas is a window to a romanticized idyll far removed from the gritty realism orbiting his studio.

A few years later, another major work – similarly refused entry to the official Salon exhibition for not conforming to its narrow, conservative pictorial requirements – was Edouard Manet's *Le Déjeuner sur l'herbe* (1863; opposite), which also paid homage to his artistic forefathers in spirit, but broke from tradition by depicting nude bathers and men socializing in modern dress, instead of aping examples from classical antiquity. Added to this sartorial scandal was the strange, compressed flatness and theatrical staginess of Manet's picnic, with its central, naked figure staring brazenly out at the viewer, resulting in a further, unwelcome incursion of everyday reality into the previously unsullied realms of high art.

It was this widening split – between the romantic and the real, the classical and the modern – which Courbet would rupture further with a method of landscape painting that defied its purpose to accurately represent visible truth. Among his many seascapes, painted on the shores of Trouville and Deauville, is a small study entitled *The Beach* (1865; ill. p. 132), which is devoid of any boats, personages, prominent waves or significant weather effects, rendering it a near-abstract evocation of a possibly windy, possibly cloudy, possibly sunny day. The topographical information is so degraded and the brushstrokes so broad and heavy, it is as if Courbet wanted only to sketch in five bands of colour, above and below the merest hint of a horizon line, among other barely discernible features of coastline. Consequently, there is little perspective or perceivable profundity to the picture, which is exacerbated by the artist's bold signature, further compressing the foreground. No romance and very little reality make this small picture neither a record nor an evocation, but an early example of art for art's sake.

The idea that a work of art might not successfully allude to its subject matter in either form or clear exposition is to suggest that it is either a failure or an unfinished sketch, in advance of a more determined, lifelike outcome. Of course, the paradox of ambiguity is that it is neither here nor there, never revealing its true identity, as is the case with Michelangelo Buonarroti's final work, the so-called *Rondanini Pietà* (1559–64; opposite), a sculpture he chiselled at for more than a decade before his death. Such were Michelangelo's incessant modifications that it is possible to see an early arm that was at some point cut free from the main torso, but remained resolutely part of the whole. The excuse that the work remained unfinished at his passing is to miss the notion that perhaps these fragments were never meant to be unified satisfactorily; indeed, the entire work demands a reappraisal of the artist's methods and motives.

Michelangelo Buonarroti,
*Pietà, known as the Rondanini
Pietà*, 1559–64. Castello
Sforzesco, Milan

Opposite Gustave Courbet,
The Beach, 1865. Wallraf-
Richartz-Museum & Fondation
Corboud, Cologne

Michelangelo had previously sculpted two versions of the subject, where the Virgin Mary takes the burden of the slumped Jesus figure, who lies prone after being taken down from the cross. However, for this final work, there is a strange symbiosis between mother and son, who both appear to be standing, or even floating weightlessly. Rather than just depicting a weakened Jesus, it is almost as if Mary was being raised up on the shoulders of Christ or being reborn as an adult. Clearly, the two figures are inseparably fused, their bodies following a singular, sinewy line from head to base – with Mary's veil flowing into her arm and, in turn, into her son's shoulder and back. Together they form a twisting trunk, like that of a tree, gnarled and misshapen with wind-bent branches and a scarified bark as surface, hardly human or lifelike at all. The only refined areas – the legs, genitals and one arm of Jesus – are also oddly thin, limp and straggly. It seems that the very life has been drained out of the sculpture, seeping out through the floor, perhaps the only real clue that this was the final piece by an artist seeking something other than the obvious truth at the end of his life's work.

Chapter 7
Art as Folly

Mix a little foolishness with your serious plans.
It is lovely to be silly at the right moment. *Horace, 20 BC*

An artist painting ridiculous, sickly-sweet confections, carnival-esque cavalcades or grotesque caricatures might be accused of pandering to populism or being prone to flights of fancy. Such works are often considered no more than ornamentation, spoof or whimsy, and are certainly not normally associated with the serious business of fine art. Yet when it comes to any Old Master collection or museum worth its salt, it is often these moments of levity, laughter or (whisper it) light entertainment that can elevate the gallery-going experience beyond that of a trudge of duty.

A titillating conversation piece, a slice of bawdy revelry or the classical equivalent of a rom-com should not be so readily dismissed. After all, the cultural impact of an accessible, quickly digested and easy-on-the-eye image can have lasting ripples. Take *The Laughing Cavalier* (1624; opposite) by Frans Hals, which has become a defining portrayal of mirth among the Old Masters, despite the fact that the swaggering sitter is merely smirking, rather than breaking out into an uproarious guffaw. Hals painted many more jaunty portraits of laughter and merriment, including busty women of dubious morals, innkeepers, gurning drunks, lute players, cheeky children and a famous red-faced jester, painted in 1643 and dubbed 'Pickled Herring', likely due to his prodigious alcoholic intake. In all of these, what Hals captured with his breezy, swift brushstrokes was both the fleeting recognition of each individual's life force in that moment, as well as a specific, often jovial mood – many creasing up their features into laughter or grinning in advance of a laugh. Such sparks of personality can leap across centuries, providing cheer while also connecting audiences with long-dead artists far quicker than any art-historical text or symbolic considerations.

Frans Hals, *The Laughing Cavalier*, 1624. The Wallace Collection, London

Art as Folly

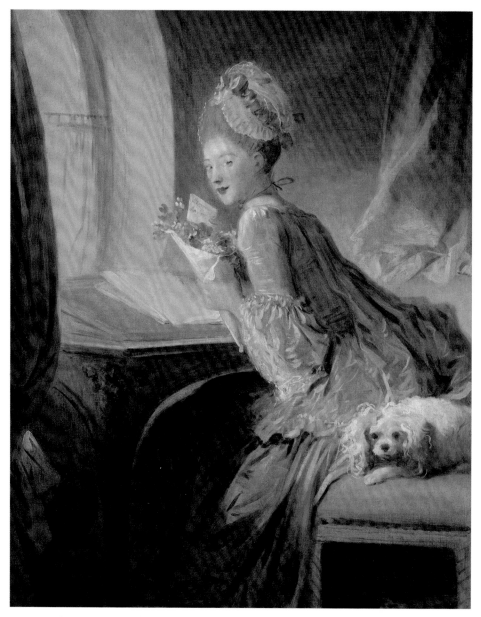

Jean-Honoré Fragonard, *The Love Letter*, early 1770s.
The Metropolitan Museum of Art, New York

Look Again

Indeed, the Old Masters were not all painters of static, stoic earnestness, honing their pictorial treatises as if preparing lectures for deep intellectual engagement. Many were keenly aware of their audience's need for escapism, comedy, or simply the kind of unchallenging fare that would suffice as a backdrop to a leisurely afternoon stroll. Why shouldn't art be fun, or even funny? And couldn't the prettiest of clothes conceal an angry or sarcastic interior?

Jean-Honoré Fragonard played to the French Rococo era's tastes for fanciful, saccharine stories of amorous liaisons and domestic intrigue in works such as *The Love Letter* (early 1770s; opposite), a voyeuristic glimpse into a lady's boudoir, where she is coquettishly allowing the viewer to see a secret missive she is about to send to her lover. The pastel shades, the bouquet of flowers and lacy details lend the picture an air of fragrant sensuality and lustful abandon. Both the protagonist's come-hither eyes and her suggestive lean invite us into the plot further, with only the faithful dog's accusatory stare representing a note of caution, lest we get further sucked into this soap opera. Fragonard's outwardly lightweight vignette exudes pure romance and pleasure, although it hints at a potentially scandalous, erotic bodice-ripper of a tale just beneath the surface, ensuring that it leaves a trail of gossip in its wake.

Even more theatrical was the work of Fragonard's contemporary, Jean-Antoine Watteau, who was famed for his *fête galantes*, imaginary, bucolic set pieces involving large groups of frolicking figures or performing folk. Slightly anomalous in his oeuvre, but no less of a masterful folly, was a full-length, life-size portrait of a clown, called *Pierrot, formerly known as Gilles* (c. 1718–19; ill. p. 138). The clown, surrounded by a number of other players from his troupe, including a character on a donkey and three other schemers lurking beneath or behind the stage, stands up straight, lonely and unsure in his ghostly white costume, perhaps not comfortable with his role of entertainer or the nightly humiliation he has to endure in front of us, the audience. Maybe Watteau conceived of it as an allegorical self-portrait, given that he painted it so close to the end of his own tragically short life. In any case, the lanky and awkward figure of Pierrot is a reminder of the struggle and sadness beneath the smile of even the jolliest clown.

138 *Look Again*

Some Old Masters went beyond subtle self-deprecation in order to wage outright satire on the world. A miniature painter (unsurprisingly anonymous) created 17 overlays for his tiny portrait of Charles I, each one showing him at a different stage in his life – being crowned, wearing the cloak of the accused in his trial, being imprisoned, then being blindfolded and, finally, with his decapitated head sat unceremoniously on the block (and two crosses for eyes, for good measure). British artist William Hogarth famously lampooned himself in his *The Painter and his Pug* (1745; above), which lovingly depicts his faithful dog Trump at his master's side, suggesting a direct likeness between them, as well as a shared 'pugnacious' nature, to use Hogarth's pun. While conjecture points to his haughty literary and theoretical references – in the books by Shakespeare and Milton propping up his portrait and the palette bearing the inscription 'The Line of Beauty (and Grace)' – I prefer to read these as ironic pointers to Hogarth's own superiority over the named authors and the physical beauty of the two specimens on display, despite one of them having its tongue hanging out.

Jean-Baptiste-Siméon Chardin, *The Ray*, c. 1725–26. Louvre, Paris

Look Again

Hogarth was chief among painter-satirists, poking fun at the vanity and scourge of both high and low society, the vagaries of married life, in addition to the dangers of drinking, gambling, indolence and everything in between. Upon his return from France in 1748, for example, he created an excoriating, farcical scene of barely concealed animosity for the neighbours over the Channel, entitled O *the Roast Beef of Old England* (*'The Gate of Calais'*), after a popular jingoistic ballad, which sang the praises of British values and culture.

His composition shows a rabble of slack-jawed soldiers and a fat French friar salivating over a huge sirloin bound for an English pub, while they are forced to survive on raw onions and weak soup. A trio of hooded hags drool over an equally unappetizing basket of fish, featuring a couple of flounder and a giant upturned skate, whose grimacing features reflect those of the old women. The artist paints himself again, this time in the act of being apprehended on enemy soil, no doubt reflecting his actual arrest as a spy for sketching at the Calais gate. Yet Hogarth is unafraid of putting himself and his views in the picture, playing the role of both unashamed provocateur and sharp-witted critic, implying that his brush is mightier than the sword (or the pen). He even wields that most harmless of weapons, humour, with menace and aplomb.

Given its peculiar ugliness, it might seem highly unlikely that any artist would devote one of his largest and most brilliant paintings to the flat and freakish-looking skate, or ray, as seen in Hogarth's parody, but this came to pass in *The Ray* (*c.* 1725–26; opposite), a huge, startling image by the maestro of still-life painting, Jean-Baptiste-Siméon Chardin. His disturbing fish hangs glistening, half-gutted, from a butcher's hook above a table laden with pots, pans, bottles and a few morsels of somewhat more tempting seafood, including oysters; looming above all of this is a cat with its tail up, ready to pounce. A knife balanced near the edge adds a sense of jeopardy and violence to the strange, grinning creature at the picture's centre, whose tragicomic features make it look alternately cheerful and sad about its own demise. A further leap is required to see this whole image as a substitute for a flayed body or a surrogate crucifixion scene, but it could well have been Chardin's ironic way of stating his artistic ambitions through the much-maligned genre of still-life painting, in place of the routinely overblown compositions favoured by history or religious painters.

Still-life paintings were not even well enough regarded in their spiritual home of the Netherlands to elevate them beyond the third grade in a system of ranking that placed this copyist's trade on the lowest rung of art-making, to the point where they were nicknamed 'little trifles'. Perhaps this stigma was what lead Chardin to not only experiment so radically by adding his leering ray to the lowly tabletop of everyday objects, but also to further pour scorn upon his chosen vocation in a series of trompe-l'oeil pictures – made seemingly only to deceive the eye, mimicking lifelike shelves or three-dimensional sculptural friezes – as well as in a possible joke self-portrait, *The Monkey Painter* (*c.* 1739–40; below), in which a capuchin dressed as an artist works away at a fresh canvas. The inference here is that the artist is no more than an imitator, 'an ape of nature', with the monkey boldly looking out at us the viewer, or even, judgmentally, at Chardin himself.

Jean-Baptiste-Siméon Chardin, *The Monkey Painter*, c. 1739–40. Louvre, Paris

Opposite David Teniers, *Monkeys in the Kitchen*, mid-1640s. The State Hermitage Museum, St Petersburg

Certainly better as an exemplar of the wider theme of 'monkey painting' – believe it or not, an Old Master sub-genre all of its own – was the Flemish artist David Teniers, who imagined a guardroom full of cheeky primate soldiers, a tavern of smoking and drinking simians, and a barbershop with scissor-wielding chimps, as well as a whole troop of *Monkeys in the Kitchen* (mid-1640s; below). In each, the mockery of human activity reflects on our own all-encompassing vanity as a species, although the kitchen scene is especially revealing, with little groupings of different hierarchies developing around the life-giving fire, a card game or a central cluster eating a sinful apple, repeating the mistake made by the first misguided people to walk this planet. The presumed leaders of this motley menagerie sit up high on stools; chief among them is surely the one who wears the faintly preposterous feathered hat. These pictures puncture our over-inflated opinions of ourselves, again proving that what looks at first like a crowd-pleasing folly or a one-liner can actually conceal a deep and vital investigation of the human condition.

Henry Fuseli, *Titania Awakes, Surrounded by Attendant Fairies, clinging rapturously to Bottom, still wearing the Ass's Head*, 1793–94. Kunsthaus, Zurich

Look Again

If unpalatable food and wild animals can be corralled into the service of revelatory art, then so can superstition, the supernatural and the spirit world. Just such an alternate fantasyland is conjured by Henry Fuseli's adaptation of a Shakespearean staple depicting Titania and Bottom from *A Midsummer Night's Dream* (1793–94), namely the scene in which the fairy queen drinks a love potion that dupes her into falling for an actor, Nick Bottom, whose head has recently been transformed into a donkey's – 'Man is but an ass,' as the Bard would have it. Amid these fantastical and hallucinatory goings-on, with insect-headed imps and flying nymphs of differing scales, is a twisted, macabre love story gone awry. Known as the 'wild Swiss artist', Fuseli explored the fine line between dreams and nightmares, fairies and demons, sprites and humans. The onlookers are also caught up in the revelry, seeming lost in the maelstrom; one of the women holds up two fingers of her hand to symbolize the devil or the stupidity of man. By unveiling a darker, gothic side to the folly of Shakespeare's comedy, Fuseli builds up a carnival-esque, bacchanalian atmosphere in which the unconscious and the imagination are allowed to run riot.

The throes of an actual carnival can be seen in another majestic panel by Pieter Bruegel the Elder, an artist last seen in the chapter on Honesty. For the *Fight Between Carnival and Lent* (1559; ill. p. 147), however, reality takes a backseat to fantasy, humour and playfulness take precedent over verisimilitude and folly rules over fact. In the market square, a fat man with a pie balanced on his head and a pig's head on a spit leads a procession through the town from atop a barrel of beer. This gluttonous chap (Carnival) is coaxing the slovenly, the masked and the treacherous into reverie, while the lepers and the beggars come limping along behind (see detail, p. 146). This is the sick, twisted family of man enjoying the freewheeling mood of feast day, whereas the right-hand side is populated by the pious and the religious, the do-gooders and the penitents, observing the 40-day hardships of Lent. Carnival's adversary in this joust is represented by an emaciated nun, armed with no more than a baker's peel and two herrings. Symbolically, the taverns (on the left) are the unruly sites of debauchery and sin, while the church (on the right) is a place of austerity and obedience. While not overtly critical of the Christian faith, not one of the 200 figures emerges unscathed by Bruegel's brush. But astoundingly, his was not even the most outrageous eye-watering, wide-angle crowd scene of the medieval era.

We also encountered Piero di Cosimo earlier in the introduction, through his double-take portrait (ill. p. 24), but he was also one of the originators of the boisterous fool's paradise-as-painting, in works such as *The Discovery of Honey by Bacchus* (*c.* 1499; overleaf), one of a pair made for a wealthy patron in Florence, who presumably liked a party himself. This ancient ritual centres on the first flush of honey found in April, here not so much precipitated by simply raiding a hive, but involving the wine god Bacchus and various other half-man, half-goat satyrs and fauns, as well as some half-drunk followers, who play their pipes and bash their instruments to lure the bees into the tree, after which they are rewarded with the sweet nectar. Other figures can be seen stirring up the hornet's nest, getting bitten and then soothing their stings in mud, or even being birthed by a tree in the middle of it all. The overall sense is of an unhinged, cod-pieced romp-com (which gets darker and more bestial in the second panel), but to which we are cordially and openly invited by the leering, spread-legged Pan in the foreground, who winks at us, thrusting out his onions suggestively.

Look Again

Pieter Bruegel the Elder, *Fight
Between Carnival and Lent*, 1559.
Kunsthistorisches Museum, Vienna

Overleaf Piero di Cosimo, *The Discovery
of Honey by Bacchus*, c. 1499. Worcester
Art Museum, Massachusetts

Art as Folly 147

The most depraved and wildest purveyor of polyphonic pictures in the entire history of art remains another great artist of the Middle Ages, Jheronimus van Aken – or Hieronymus Bosch – who identified a grotesque and ribald side in everything he painted, often amplifying the most microscopic bug life or vice-ridden practices into full-bore mirages of the mind. At his simplest, we find a small work such as *The Cure of Folly* (1475–80), in which a nun, a monk and a clearly unqualified doctor perform some kind of trepanning operation on a poor victim, supposedly to rid the man of his naughty thoughts, which horrifyingly documents a real practice of medieval quackery. For all the allegorical figures we have seen in Old Master images – of those who have succumbed to greed, thievery, slovenly behaviour or insolence – such cautionary characters were often not fictional figures of fun, but based on grim reality.

The full madness of mankind is revealed in Bosch's masterpiece, *The Garden of Earthly Delights* (1490–1500; overleaf), a troubling triptych that begins with the relative calm and utopia of Eden on the left, and quickly descends into a conflagration of what looks like every imaginable human interaction occurring all at once (see detail, opposite), followed finally by a hellscaped premonition of civilization's inevitable, fiery end. Entire volumes could be filled just by trying to describe the hysterical and cataclysmic events unfolding over these three hectic compositions, and indeed, I have donned a virtual-reality headset that plunged me deep into Bosch's tripartite masterpiece, although the experience was nowhere near as immersive as the painting itself.

Suffice it to say that the appearance of such terrifying sights as disfigured tree monsters, mutated winged creatures and marauding demons might give the lasting impression that Bosch was merely a doomsayer depicting a ghastly apocalypse that has never come. However, there is both humour and horror in the naked men and women cavorting with birds and beasts, often to be reincarnated as something else, in that every figure is doing something to someone else; everyone is both victim and perpetrator of some outrageous sin or inappropriate behaviour. Perhaps there is a more complex narrative among all the recurring semi-spherical symbols, including eggs, shells, seeds and strawberries, which conveys nature's regenerative circularity, not to mention its innate weirdness, as well as our holistic relationship with all other living things. It is a cavalcade through time, morality and evolution, amounting to a sort of artistic exorcism or therapy, through which – like the T.A.B.U.L.A. formula – we approach

spiritual karma and enlightenment only after navigating the darkest reaches of our souls and learning from the mistakes of the fallen. Such trips into the unconscious and the unknown have been excused as flights of folly or delirium on the part of the artists responsible, but for me they rank as some of the highest achievements of our culture, stemming from a powerful inner creativity, or an unadulterated artistic vision, as we shall now see.

Hieronymus Bosch, *The Garden of Earthly Delights* (detail)

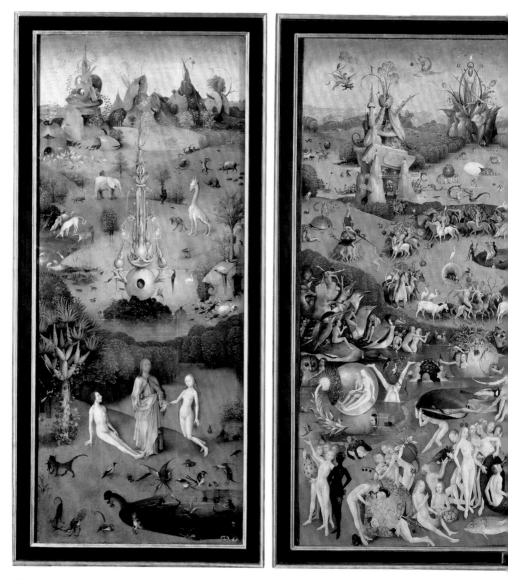

Hieronymus Bosch, *The Garden of Earthly Delights*, 1490–1500. Museo del Prado, Madrid

Look Again

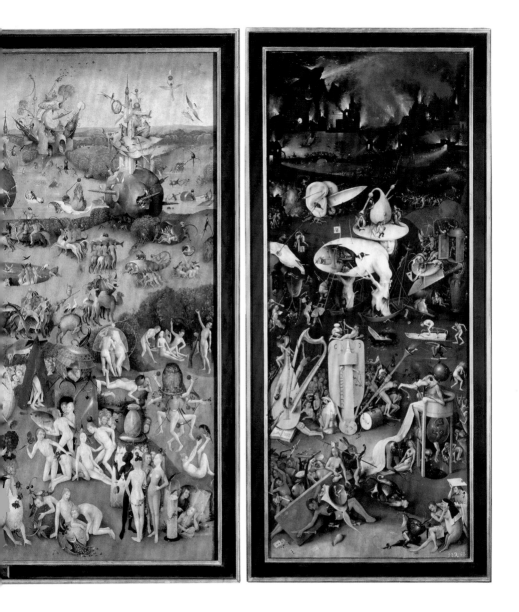

Chapter 8
Art as Vision

The question is not what you look at, but what you see.
Henry David Thoreau, 1851

The history of art is littered with anomalies: artists who were out of
their time, maybe ahead of it, perhaps even far behind it. These unique
figures – rarely part of a recognized movement or a cultural zeitgeist –
were often considered mad, bad or dangerous to know, but their radical
contributions to art should not be reduced to the margins. Some of
these artists provide shining beacons in dark times and light the way for
future generations. Whether these visionaries were obsessed by a private,
fictional world or were able to tap into moments of extreme natural
spectacle, they deserve their place in the pantheon.

Many of these artists – a longer list than is possible to illustrate
here (to which I would surely add many others from previous chapters,
including Bosch, Velázquez, Goya, Michelangelo and Rembrandt) –
did not fit the canon, so much as invent a new path all of their own. For
that reason their legacy is sometimes disputed – if not now, then certainly
during their lifetimes. More than artists, these figures can be regarded
as seers, soothsayers or pioneers of imaginative thinking and creation.
Such intangible influence would not often translate into immediate
success or understanding. William Blake – poet, spiritualist and prophet,
as much as an artist – did not sit easily within academic circles and never
climbed the ranks in the same manner as his younger contemporaries,
Turner and Constable. A self-confessed visionary, he claimed to have
seen angels, aged eight, and conversed with ghosts not long after, but it
is equally facile to assume his art was simply the result of a feverish and
troubled mind.

Blake's vision stemmed very much from ancient precursors and the
Old Masters, even if his work neither resembled nor paid direct homage
to them. Rather, he was an old soul trapped in a swiftly modernizing

William Blake, *A Small Book of Designs/The First Book of Urizen*, 1794. The British Museum, London

world. He toiled away on prints of famous paintings or illustrations of epic poems, as well as on personal books and private engravings, and created his own cast of characters, including Los, representing the imagination of man, whose fate is to create the figure of Urizen, who in turn represents the tangible, rational domain. In a page from *The First Book of Urizen* (1794; ill. p. 155), captioned 'Los howl'd in dismal stupor', Los laments his decision to form this mortal creature, intertwining the tale of Adam and Eve from Genesis, with the eventual Fall of Man.

Blake bemoans the intransigence of those less religiously inclined or less nimble of thought than he; in other words, those who weren't constantly staring upwards at the sky like Blake himself. He even depicted the father figure of gravity and natural sciences, Sir Isaac Newton, as a self-obsessed scientist in an eerie underwater setting (1795–*c.* 1805; above),

bent on using his compass only to fashion a geometrical, unenlightened world. Railing against the rest of the planet, Blake was destined to be his own judge, jury and executioner, producing an esoteric art for an audience of one at a time when no one would listen to his ravings – until, that is, the rest of existence caught up with and accepted his mythical visions.

Another artist out of step with his time, but always looking up to the firmament or beyond the mortal bounds of life, was El Greco, or Doménikos Theotokópoulos to give him his full name. In the crowning work of a long and glittering career – which started off with traditional Greek icons in gold paint and ended with his version of the end of days in *The Opening of the Fifth Seal* (1608–14) – El Greco visualized the laying to rest of a famous patron of a church in Toledo, Spain, as a commission for the very same parish where he had settled in later life. *The Burial of*

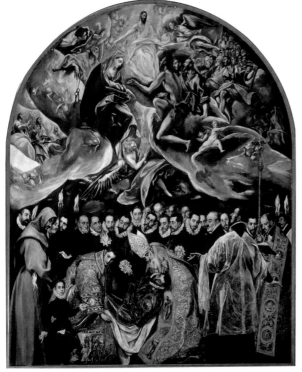

El Greco, *The Burial of the Count of Orgaz*, 1587. Iglesia de Santo Tomé, Toledo

Opposite William Blake, *Newton*, 1795–c. 1805. Tate, London

Overleaf El Greco, *The Burial of the Count of Orgaz* (detail)

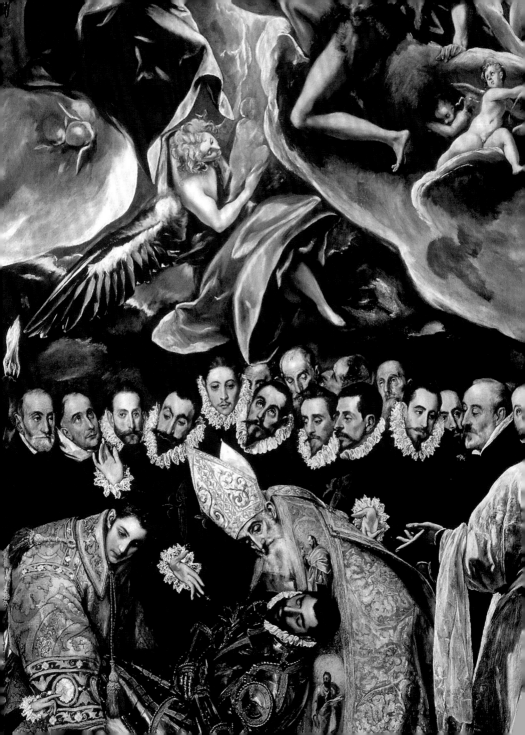

the Count of Orgaz (1587; ill. p. 157) depicts a religious miracle of 300 years earlier when the count was apparently lowered into his tomb by none other than the long-dead saints Stephen and Augustine, themselves descended from above (see detail; opposite).

Filling an entire wall of the church and painted life size are not only the local clergy and mourning nobility in their finest clothing (albeit three centuries after the actual event), but also a whole array of other stellar onlookers, including the Holy Family and scores of attendant angels in a great swirl of distended limbs, flowing robes and angelic wings. Almost comically unruffled that Noah, Lazarus and Moses are among those overseeing this funeral from on high, the assembled phalanx of the living in the lower half also contains El Greco's son, staring out at us while kneeling theatrically on the frame of the picture, pointing to the real miracle, that of his father's incredible pictorial achievement. Indeed, so convincing is the artist's vision of the meeting of the real and the spirit worlds that it is also no surprise to see the ghostly, childlike soul of the count being personally escorted through the clouds up to the pearly gates. Aside from the virtuosity of the painting, it was the conflicting styles found in the later work of El Greco, partway between the recognized eras of the Renaissance, Mannerism and Baroque, yet adhering to none, which set him so far apart from his peers and places him outside their ranks, as a visionary.

An even more ambitious pictorial gathering is realized in Gentile Bellini's *Procession in Piazza San Marco* (1496; ill. p. 160), which occupies an enormous panel in the Gallerie dell'Accademia in Venice, located only a stone's throw away from the setting of the painting, the main square in the city. Like El Greco's composition, this work is divided horizontally, with the upper half devoted to the architectural trappings of the Doge's Palace and the multiple, repeating domes and archways of St Mark's Basilica, whereas the lower half is chock-full of Venetians, many following the parade in honour of a fragment of the True Cross, protected by its gold canopy and casket. This relic is the subject of an unseen miracle, signalled by the kneeling man just visible through a break in the procession (see detail; p. 161), whose prayers were answered upon returning home, where he found his dying son had been entirely healed of his ills. This pause amid the bustle of merchants and citizens shows how the mysterious and divine is at work around us – every day and at all times – and how the smallest detail might disrupt even the biggest

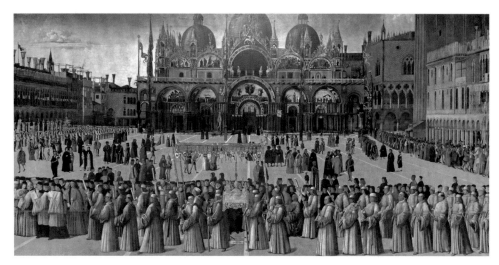

Gentile Bellini, *Procession in Piazza San Marco*, 1496. Gallerie dell'Accademia, Venice

event or elucidate a much larger whole. What little we can see of the man dressed in red robes and genuflecting before this holy fragment of wood still manages to evoke the suggestion of spiritual enlightenment, even though the wider public cannot directly share in his very private vision.

Another Bellini, Giovanni, often helped his older brother paint these vast works towards the end of Gentile's life – including another miracle in which the same portion of the cross was dropped from a bridge, only to magically hover above the canal until its retrieval – and was responsible for a number of visionary works of his own. Again depicting a moment of ecstasy that we cannot see, occurring just outside the frame (as if off-camera), is his *St Francis in the Desert* (c. 1476–78; ill. p. 162), which shows a monkish figure alone in an epic landscape, undergoing some kind of intense experience and bathed in a stream of golden light. While there is no denying this man's piety – he is shown contemplating a skull and a crown of thorns on a simple cross, while standing in front of a hermit-like cell wearing the hooded robe of a Franciscan friar, the three knots signifying obedience, poverty and chastity – what he is receiving is unclear and left to our imagination. Lost and enrapt, the figure seems

Look Again

to be transformed before our eyes, perhaps morphing and becoming one with the mountainside behind him (one suggestion is that the entire hill reflects the shape of his bare, outstretched left foot).

While many of these artists portrayed apocryphal or literal visions, the Old Masters who most furthered the cause of the visionary, singular voice were those who developed idiosyncratic ways of seeing or fresh perspectives for picturing the world, and would lead the way for a breed of New Masters. It may have seemed that these mavericks were undoing or unlearning all that the so-called Old Masters had pioneered or taught previous to 1800, deconstructing their predecessors, simplifying and reducing, complicating and recoding the entire process. Consequently, most of them faced ridicule, critique and penury in their lifetimes, but soon the boundaries they were pushing against – of what was acceptable or understandable as art – would begin to fall, one by one. Indeed, this process can also be seen as the death knell for our R.A.S.A. categories of Rhythm, Allegory, Structure and Atmosphere.

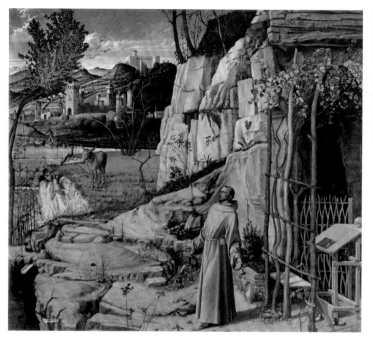

Giovanni Bellini,
*St Francis in the
Desert*, c. 1476–78.
The Frick Collection,
New York

Opposite Paul Cézanne,
*Montagne Sainte-
Victoire with Large
Pine*, c. 1887. The
Courtauld Gallery,
London

Chief among the influx of New Masters – which some would argue began with the French Realists (Courbet, Delacroix, Géricault), or even date as far back as Goya in Spain – were those who became banded together as the Impressionists in 19th-century Paris, starting with Manet and Edgar Degas and peaking with Claude Monet. Working quickly and *en plein air* to produce their immediate 'impressions', rather than solemnly reworking and finishing canvases in the studio, these painters moved towards abstraction with fleeting, gestural stabs of colour and impulsive bursts of light. Paul Cézanne's meditative and cumulative study of a single landscape, around Mount Sainte-Victoire in the south of France, saw him dispense with such traditional painterly tenets as depth, clarity, detail, line and integrity, preferring instead radical simplification; fracturing, flatness, faceted surfaces and coloured planes.

Look Again

Across dozens of oils and watercolours, including *Montagne Sainte-Victoire with Large Pine* (*c.* 1887; above), he repeated the same mountainous view over and over, until the very ground beneath the rock appears to vibrate and shimmer, while the land threatens to dissolve into the sky. Despite Cézanne's strict adherence to the observation of his subject matter, each image appears radically different, his inability to match his ambition leaving doubts in his mind as to the need for painterly description. By feverishly swiping away paint and increasingly leaving fissures of untouched canvas, his brushstrokes succeeded in reflecting his own unrest and uncertainty over this defining project, to which he nevertheless devoted most of his final years.

This unfaithfulness towards the real or the retinal was continued and further exploited by Monet, who also somehow managed, like Cézanne, to stay true to the ambiance of what was in front of him (even though I would have to concede that my definition of what constitutes the Atmosphere of a painting begins to break down during the height of Impressionism). Again, we can be sure of the source material for Monet's greatest endeavour, a series of over 250 oil paintings, which was devoted to the elaborate pond he had specially dug and filled with lily pads at his garden in Giverny (often swapping canvases as the time of day changed).

Although stemming from his own exacting vision of what constitutes the glory of nature, his water lilies were not so much perceived and relayed to the audience in image after image, as gradually and progressively explained and experienced over time. This is perhaps unwittingly continued in their afterlife as a disparate collection of interrelated paintings, spread all over the world and found in differing contexts, whether at the Musée de l'Orangerie in Paris (below), the Metropolitan Museum in New York or at the Chichu Art Museum on the island of Naoshima in Japan – all of which contain expansive, circular or enveloping friezes of water lilies that surround and overwhelm the viewer with Monet's vision.

The relative solidity of Cézanne's massif collapses into airiness and space in Monet's watery scenes, although often great, thick daubs of hardly mixed paint were plastered directly to the surface to convey the immediacy of the artist's response to the watery ripples of the ponds. The lilies themselves are also half-formed, barely there entities, sketched

Claude Monet, *Water Lilies: The Clouds*, c. 1915–26. Musée de l'Orangerie, Paris

Look Again

with rapid dashes and a dizzying range of strokes, harmoniously building up towards their eventually radiant, tactile state. Although Monet, too, honed his art through endless repetition, it was towards the sheer radicalization of form that he toiled, approaching some kind of universal truth, or at the very least, an attainment of simultaneously micro- and macro-realities. Close up, the pictures disperse into molecular, cellular nodes of colour, with no lines to support these free radicals, roaming about the canvas. And yet, from a few steps back, a coherent view comes into focus and reality is restored. Perhaps all we are left with is this numinous substance of atmosphere, of feeling, of hints and nudges.

What occurs in a painting when it proposes an instantaneous reaction with no link to history whatsoever, and we are consequently deprived of all sense of Time, Association, Background, Rhythm, Allegory, Structure, and so on? In 1878 just such an argument raged in a British court, about what constituted an artwork when it had been loosened from the moorings of convention. The Anglo-American painter James Abbott McNeill Whistler had to defend his work from libel, in the face of severe criticism, including claims that it formed a 'dangerous precedent', and that the artist was 'flinging a pot of paint in the public's face'. This last barb came from the pen of John Ruskin, the father figure of the Victorian art establishment, who was too frail to appear at the trial in person to further denounce Whistler's radical handling of a fireworks display at night, entitled *Nocturne in Black and Gold, the Falling Rocket* (1875; ill. p. 166). The artist himself pleaded that while it may have only taken two days to paint, it contained a lifetime's worth of experience.

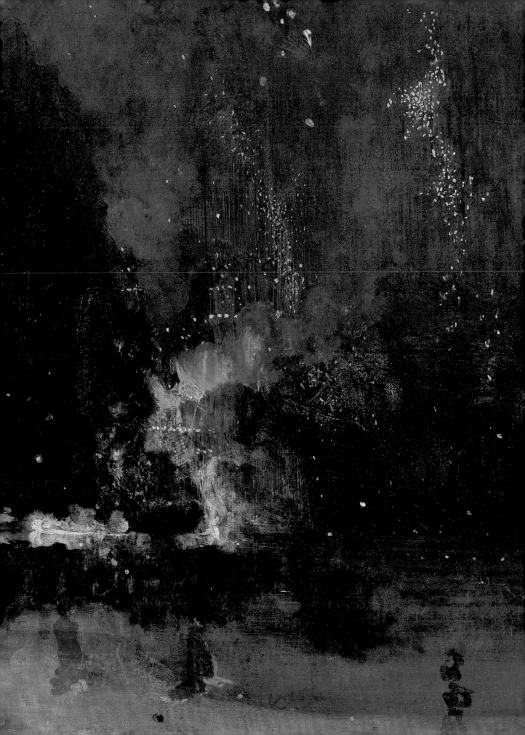

Ruskin lost the case, and Whistler was awarded less than a penny for his troubles, filing for bankruptcy and departing for Italy not long after. The *Nocturnes* series, of which he painted 22, have since become renowned for the artist's handling of a landscape in semi-darkness, capturing such impossibilities in paint as smoke and vapour hovering over the Thames. Like a partially developed photograph or a suite of musical compositions, works such as *Nocturne: Blue and Silver – Chelsea* (1871; below), which shows only a barge and a fisherman silhouetted against moonlight in place of any painterly pyrotechnics, reach for the unattainable – certainly atmosphere, certainly rhythm, but also an absolute beginning, perhaps returning us to the T.A.B.U.L.A. R.A.S.A., the blank slate. It wouldn't be long – the turn of the century was fast approaching – before artists reduced their palette and references to outward reality even further, starting from a white page, an empty canvas, and turning the clock back to year zero. Seeing was about to become harder, and saying nothing would become a new language all of its own. This is what it must have been like to look at the future.

James Abbott McNeill Whistler, *Nocturne: Blue and Silver – Chelsea*, 1871. Tate, London

Opposite James Abbott McNeill Whistler, *Nocturne in Black and Gold, the Falling Rocket*, 1875. Detroit Institute of Arts

List of illustrations

Measurements are given in centimetres,
followed by inches in brackets

2 Rembrandt van Rijn, *Ahasuerus and
Haman at the Feast of Esther*, 1660. Oil
on canvas, 73 × 94 (28¾ × 37⅛). Pushkin
Museum of Fine Arts, Moscow. Photo 2019
Scala, Florence

15 John Constable, *Study of Cirrus
Clouds*, c. 1822. Oil on paper,
11.4 × 17.8 (4½ × 7⅛). Victoria & Albert
Museum, London

17 Johannes Vermeer, *Girl Reading a
Letter at an Open Window*, 1657–59.
Oil on canvas, 83 × 64.5 (32¾ × 25½).
Gemäldegalerie Alte Meister, Dresden

19 Jacques-Louis David, *The Death of
Marat*, 1793. Oil on canvas, 165 × 128
(65 × 50½). Royal Museums of Fine Arts
of Belgium, Brussels

20–21 Paolo di Dono, called Uccello,
The Hunt in the Forest, c. 1465–70.
Tempera and oil on panel, with
traces of gold, 73.3 × 177 (28⅞ × 69¾).
Ashmolean Museum, University of Oxford

24 Piero di Cosimo, *Portraits
of Giuliano and Francesco Giamberti
da Sangallo*, 1482–85. Oil on panel,
47.5 × 33.5 (18¾ × 13¼). Rijksmuseum,
Amsterdam

26 Jan van Eyck, *The Crucifixion;
The Last Judgment*, c. 1440–41.
Oil on canvas, transferred from wood,
each panel 56.5 × 19.7 (22¼ × 7¾).
The Metropolitan Museum of Art, New
York. Fletcher Fund, 1933. Photo 2019
The Metropolitan Museum of Art/Art
Resource/Scala, Florence

30 Leonardo da Vinci, *The Last Supper*,
1494–98. Tempera and oil on plaster,
460 × 880 (181⅛ × 346½). Church of
Santa Maria delle Grazie, Milan

32 Giovanni Battista Tiepolo, *Allegory
of the Planets and Continents*, 1752.
Oil on canvas, 185.4 × 139.4 (73 ×
55). The Metropolitan Museum of Art,
New York. Gift of Mr and Mrs Charles
Wrightsman, 1977

34 Piero della Francesca, *The Baptism
of Christ*, after 1437. Egg on
poplar, 167 × 116 (65¾ × 45¾). National
Gallery, London

37 J. M. W. Turner, *Norham Castle,
Sunrise*, c. 1845. Oil on canvas,
90.8 × 121.9 (35¾ × 48). Tate, London.
Accepted by the nation as part of
the Turner Bequest 1856. Photo 2019
Tate, London

39 Nicolas Poussin, *Landscape with
St John on Patmos*, 1640. Oil on canvas,
100.3 × 136.4 (39½ × 53⅝). Art Institute
of Chicago. A. A. Munger Collection,
1930.500

40 Raphael, *The School of Athens*, 1508–11.
Fresco, 500 × 770 (196⅞ × 303¼). Room
of the Segnatura, Vatican

42 Johann Heinrich Wilhelm Tischbein,
Goethe in the Roman Campagna, 1787.
Oil on canvas, 164 × 206 (64⅝ × 81⅛).
Städel Museum, Frankfurt

43 Albrecht Dürer, *Melencolia I*, 1514.
Engraving, 24 × 18.5 (9½ × 7¼). The
Metropolitan Museum of Art, New York.
Harris Brisbane Dick Fund, 1943

44 Jean-Baptiste-Siméon Chardin, *Glass
of Water and Coffeepot*, c. 1761. Oil
on canvas, 32.4 × 41.3 (12¾ × 16¼).
Carnegie Museum of Art, Pittsburgh,
PA. Howard A. Noble Fund

46–47 Pieter Claesz, *Still Life with
a Skull and a Writing Quill*, 1628.
Oil on wood, 24.1 × 35.9 (9½ × 14⅛).
The Metropolitan Museum of Art,
New York. Rogers Fund, 1949

48 Francisco de Zurbarán, *Agnus Dei*,
1635–40. Oil on canvas, 37.3 × 62
(14¾ × 24½). Museo del Prado, Madrid

50 Nicolas Poussin, *The Arcadian
Shepherds, or Et in Arcadia Ego*,
1638–40. Oil on canvas, 85 × 121
(33½ × 47¾). Louvre, Paris.
Photo RMN-Grand Palais (Musée du
Louvre)/Stéphane Maréchalle

53 Attributed to Juan Martínez Montañés
and unknown painter, *The Virgin of
the Immaculate Conception*, c. 1628.
Painted and gilded wood, 144 × 49 ×
53 (56¾ × 19⅜ × 20⅞). Church of the
Anunciación, Seville University. Photo
Daniel Salvador-Almeida Gonzalez

54 Francisco de Zurbarán, *The Crucifixion*,
1627. Oil on canvas, 290.3 × 165.5 (114⅜
× 65¼). Art Institute of Chicago.
Robert A. Waller Memorial Fund, 1954.15

55 Eugène Delacroix, *Le Lit Défait*, 1825–
28. Watercolour, 18.5 × 29.9 (7⅜ × 11⅞).
Louvre, Paris. Photo RMN-Grand Palais
(Musée du Louvre)/Michel Urtado

56 (above) Gustave Caillebotte,
The Floor Planers, 1875. Oil on canvas,
102 × 146.5 (40¼ × 57¾). Musée d'Orsay,
Paris. Gift of Caillebotte's
heirs through the intermediary
of Auguste Renoir

56 (below) Gustave Caillebotte, *Paris
Street; Rainy Day*, 1877. Oil on
canvas, 212.2 × 276.2 (83½ × 108¾).
Art Institute of Chicago. Charles H.
and Mary F. S. Worcester Collection,
1964.33

58 Pieter Bruegel the Elder,
The Harvesters, 1565. Oil on
wood, 116.5 × 159.5 (45⅞ × 62⅞).
The Metropolitan Museum of Art,
New York. Rogers Fund, 1919

60 Aelbert Cuyp, *Herdsmen with Cows*,
mid-1640s. Oil on canvas, 101.4 × 145.8
(40 × 57½). Dulwich Picture Library,
London. Bourgeois Bequest, 1811

61 Pieter de Hooch, *A Mother Delousing
her Child's Hair, known as 'A Mother's
Duty'*, c. 1658-60. Oil on canvas,
52.5 × 61 (20¾ × 24). Rijksmuseum,
Amsterdam. On loan from the City of
Amsterdam, A. van der Hoop Bequest

63 Canaletto, *The Stonemason's Yard*,
c. 1725. Oil on canvas, 123.8 × 162.9
(48¾ × 64¼). National Gallery, London.
Sir George Beaumont Gift, 1823,
passed to the National Gallery, 1828

64–65 Bernardo Bellotto, *The Ruins of
the Old Kreuzkirche, Dresden*, 1765.
Private collection. Photo Bonhams,
London/Bridgeman Images

66 Sir Joshua Reynolds, *Omai*, c. 1776.
Oil on canvas, 236 × 145.5 (93 × 57⅜).
Private collection

68 Diego Velázquez, *Juan de Pareja*, 1650.
Oil on canvas, 81.3 × 69.9 (32 × 27½).
The Metropolitan Museum of Art,
New York. Purchase, Fletcher and
Rogers Funds, and Bequest of Miss
Adelaide Milton de Groot (1876–1967),
by exchange, supplemented by gifts
from friends of the Museum, 1971

69 Attributed to the Isidora Master,
Mummy Portrait of a Woman, AD 100.
Encaustic on wood, gilt, linen,
47.9 × 36 (18⅞ × 14⅛). The J. Paul Getty
Museum, Los Angeles, 81.AP.42

71 John Martin, *Pandemonium*, 1841.
Oil on canvas, 123 × 184 (48½ × 72½).
Louvre, Paris. Photo RMN-Grand Palais
(Musée du Louvre)/Gérard Blot

72 Michelangelo Merisi da Caravaggio,
The Taking of Christ, 1602. Oil on
canvas, 135.5 × 169.5 (53⅜ × 66¾).
National Gallery of Ireland, Dublin.
On indefinite loan to the National
Gallery of Ireland from the Jesuit
Community, Leeson St, Dublin, who
acknowledge the kind generosity of
the late Dr Marie Lea-Wilson, 1992,
L.14702. Photo National Gallery of
Ireland

74 Artemisia Gentileschi, *Judith
Beheading Holofernes*, c. 1620.
Oil on canvas, 146.5 × 108 (57¾ × 42⅝).
The Uffizi, Florence

75 Jusepe de Ribera, *The Martyrdom of
St Bartholomew*, 1634. Oil on canvas,
104 × 113 (41 × 44½). National Gallery
of Art, Washington. Gift of the 50th
Anniversary Gift Committee, 1990.137.1

76–77 Théodore Géricault, *The Raft of
the Medusa*, 1819. Oil on canvas,
491 × 716 (193⅜ × 282). Louvre, Paris.
Photo RMN-Grand Palais (Musée du
Louvre)/Michel Urtado

79 Peter Paul Rubens, *Tiger, Lion and
Leopard Hunt*, 1615-17. Oil on canvas,
248.2 × 318.3 (97¾ × 125⅜). Musée des
Beaux Arts, Rennes.
Photo 2019 Josse/Scala, Florence

80–81 An Jung-sik, *View of Yeonggwang
Town*, 1915. Ink and light colours on
silk, 170 × 473 (67 × 186½). Leeum,
Samsung Museum of Art, Seoul

82 Salvator Rosa, *The Death of
Empedocles*, c. 1665-70. Oil on canvas,
135 × 99 (53¼ × 39). Private collection

84 Thomas Cole, *The Course of Empire:
Destruction*, 1836. Oil on canvas
(relined), 99.7 × 161.3 (39¼ × 63½).
New-York Historical Society. Gift of
The New-York Gallery of the Fine Arts

86 Lucas Cranach, *Fountain of Youth*,
1546. Oil on lime panel, 122.5 ×
186.5 (48¼ × 73½). Gemäldegalerie,
Berlin. Photo 2019 Jörg P. Anders/
Scala, Florence/bpk, Bildagentur für
Kunst, Kultur und Geschichte, Berlin

89 Leonardo da Vinci, *Lady with an
Ermine*, c. 1490. Oil on canvas, 54.8 ×
40.3 (21⅝ × 15⅞). Princes Czartoryski
Museum, Kraków

91 Sandro Botticelli, *Birth of Venus*, c.
1485. Tempera on canvas, 172.5 × 278.5
(68 × 109¾). The Uffizi, Florence
93 Jean-Auguste-Dominique Ingres,
*The Bather, known as 'The Valpinçon
Bather'*, 1808. Oil on canvas,
146 × 97 (57½ × 38¼). Photo Louvre,
Paris/Bridgeman Images
94 Lawrence Alma-Tadema, *The Roses of
Heliogabalus*, 1888. Oil on canvas,
132.7 × 214.4 (52¼ × 84½). Collection
Juan Antonio Pérez Simón, Mexico
96 Titian, *Venus with a Mirror*, c. 1555.
Oil on canvas, 124.5 × 105.5 (49 × 41⅜).
National Gallery of Art, Washington.
Andrew W. Mellon Collection 1937.1.34
97 Peter Paul Rubens, *Nymphs and
Satyrs*, 1638–40. Oil on canvas,
139.7 × 167 (55 × 65¾). Museo
del Prado, Madrid. Photo 2019
MNP/Scala, Florence
100 Johannes Vermeer, *The Milkmaid*,
c. 1660. Oil on canvas, 45.5 × 41
(18 × 16¼). Rijksmuseum, Amsterdam.
Purchased with the support of the
Vereniging Rembrandt, 1908
102–3 Fra Angelico, *Annunciation*,
1438–45. Fresco, 230 × 297 (90⅝ × 117).
Monastery of San Marco, Florence
105 Matthias Grünewald, *The Isenheim
Altarpiece*, 1512–16. Tempera and
oil on panel, 269 × 307 (106 × 120⅞).
Unterlinden Museum, Colmar.
Photo Musée Unterlinden, Colmar/
Bridgeman Images
106–7 Hans Holbein, *The Dead Christ in the
Tomb*, 1521–22. Oil on canvas, 200 × 30.5
(78¾ × 12½). Kunstmuseum Basel
108 Andrea Mantegna, *The Dead Christ and
Three Mourners*, 1470–74. Tempera on
canvas, 68 × 81 (26⅞ × 32). Pinacoteca
di Brera, Milan
110–11 Francisco de Goya, *The Third of May
1808 in Madrid, or 'The Executions'*,
1814. Oil on canvas, 268 × 347
(105⅝ × 136⅝). Museo del Prado, Madrid
113 Antoine-Jean Gros, *Bonaparte Visiting
the Victims of the Plague at Jaffa,
March 11, 1799*, 1804. Oil on canvas,
523 × 715 (206 × 281½). Louvre, Paris.
Photo RMN-Grand Palais (Musée du
Louvre)/Thierry Le Mage
114 Francisco de Goya, *Saturn Devouring
his Son*, 1820–23. Oil mural
transferred to canvas, 143.5 × 81.4
(56½ × 32⅛). Museo del Prado, Madrid

116 Tommaso Masaccio, *Adam and Eve
Banished from Paradise*, c. 1427.
Fresco. Brancacci Chapel,
Santa Maria del Carmine, Florence
117 Hans Baldung Grien, *Death and the
Woman*, c. 1520. Oil and tempera on
lime wood, 29.8 × 17.1 (11¾ × 6¾).
Kunstmuseum Basel
119 Titian, *Apollo and Marsyas*, 1550–76.
Oil on canvas, 220 × 204 (86⅝ × 80⅜).
Archdiocesan Museum Kroměříž,
Olomouc. Photo Zdeněk Sodoma
121 Johannes Vermeer, *The Art of
Painting*, c. 1666–68. Oil on
canvas, 120 × 100 (47¼ × 39⅜).
Kunsthistorisches Museum, Vienna
123 Francisco de Goya, *The Family of
Carlos IV*, 1800. Oil on canvas,
280 × 336 (110½ × 132⅜). Museo del
Prado, Madrid
124 Diego Velázquez, *Las Meninas*, 1656.
Oil on canvas, 320.5 × 281.5
(126¼ × 110⅞). Museo del Prado, Madrid
127 Caspar David Friedrich, *Wanderer
Above the Sea of Fog*, c. 1817. Oil
on canvas, 94.8 × 74.8 (37⅜ × 29½).
Kunsthalle Hamburg
128–29 Gustave Courbet, *The Artist's
Studio, a real allegory summing up
seven years of my artistic and moral
life*, c. 1854–55. Oil on canvas,
361 × 598 (142¼ × 235½). Musée d'Orsay,
Paris. Photo Musée d'Orsay, Dist.
RMN-Grand Palais/Patrice Schmidt
130 Edouard Manet, *Lunch on the Grass
(Le Déjeuner sur l'herbe)*, 1863.
Oil on canvas, 208 × 264.5 (82 × 104¼).
Musée d'Orsay, Paris. Etienne
Moreau Nélaton donation, 1906.
Photo RMN-Grand Palais (Musée
d'Orsay)/Hervé Lewandowski
132 Gustave Courbet, *The Beach*, 1865.
Oil on canvas, 53.5 × 64 =(21⅛ × 25¼).
Wallraf-Richartz-Museum & Fondation
Corboud, Cologne. Photo Rheinisches
Bildarchiv, rba_c004959
133 Michelangelo Buonarroti, *Pietà,
known as the Rondanini Pietà*, 1559–64.
Marble, height 195 (76⅞). Castello
Sforzesco, Milan. Photo Azoor Photo/
Alamy Stock Photo
135 Frans Hals, *The Laughing Cavalier*,
1624. Oil on canvas, 83 × 67.3 (32¾ ×
26½). The Wallace Collection, London.
Photo Wallace Collection, London/
Bridgeman Images

136 Jean-Honoré Fragonard, *The Love Letter*, early 1770s. Oil on canvas, 83.2 × 67 (32¾ × 26⅜). The Metropolitan Museum of Art, New York. The Jules Bache Collection, 1949

138 Jean-Antoine Watteau, *Pierrot, formerly known as Gilles*, c. 1718–19. Oil on canvas, 185 × 150 (72⅞ × 59⅛). Louvre, Paris. Photo Louvre, Paris/ Bridgeman Images

139 William Hogarth, *The Painter and his Pug*, 1745. Oil paint on canvas, 90 × 69.9 (35½ × 27⅝). Tate, London. Photo 2019 Tate, London

140 Jean-Baptiste-Siméon Chardin, *The Ray*, c. 1725–26. Oil on canvas, 114 × 146 (45 × 57½). Louvre, Paris

142 Jean-Baptiste-Siméon Chardin, *The Monkey Painter*, c. 1739–40. Oil on canvas, 73 × 59 (28¾ × 23¼). Louvre, Paris. Photo RMN-Grand Palais (Musée du Louvre)/René-Gabriel Ojéda

143 David Teniers, *Monkeys in the Kitchen*, mid-1640s. Oil on canvas, 36 × 50 (14¼ × 19¾). The State Hermitage Museum, St Petersburg. Photo The State Hermitage Museum/ Vladimir Terebenin

144 Henry Fuseli, *Titania Awakes, Surrounded by Attendant Fairies, clinging rapturously to Bottom, still wearing the Ass's Head*, 1793–94. Oil on canvas, 169 × 135 (66⅝ × 53¼). Kunsthaus Zurich. Photo Kunsthaus Zurich/Bridgeman Images

147 Pieter Bruegel the Elder, *Fight Between Carnival and Lent*, 1559. Oil on wood, 118 × 164.5 (46½ × 64⅞). Kunsthistorisches Museum, Vienna

148–49 Piero di Cosimo, *The Discovery of Honey by Bacchus*, c. 1499. Painting on panel, 79.2 × 128.5 (31¼ × 50⅝). Worcester Art Museum, MA. Photo Worcester Art Museum/ Bridgeman Images

152–53 Hieronymus Bosch, *The Garden of Earthly Delights*, 1490–1500. Grisaille, oil on oak panel, 205.6 × 386 (81 × 152). Museo del Prado, Madrid

155 William Blake, *A Small Book of Designs/ The First Book of Urizen*, 1794. Relief etching, 11.9 × 10.5 (4⅘ × 4⅛). The British Museum, London. Photo The Trustees of the British Museum

156 William Blake, *Newton*, 1795–c. 1805. Colour print, ink and watercolour on paper, 40 × 60 (15¾ × 23⅝). Tate, London. Presented by W. Graham Robertson 1939. Photo 2019 Tate, London

157 El Greco, *The Burial of the Count of Orgaz*, 1587. Oil on canvas, 480 × 360 (189 × 360). Iglesia de Santo Tomé, Toledo. Photo 2019 Scala, Florence

160 Gentile Bellini, *Procession in Piazza San Marco*, 1496. Tempera and oil on canvas, 367 × 745 (144½ × 293⅜). Gallerie dell'Accademia, Venice

162 Giovanni Bellini, *St Francis in the Desert*, c. 1476–78. Oil on panel, 124.1 × 140.5 (48⅞ × 55⅜). The Frick Collection, New York. Henry Clay Frick Bequest. Photo 2019 Fine Art Images/ Heritage Images/Scala, Florence

163 Paul Cézanne, *Montagne Sainte-Victoire with Large Pine*, c. 1887. Oil on canvas, 66.8 × 92.3 (26⅜ × 36¼). The Courtauld Gallery, London

164–65 Claude Monet, *Water Lilies: The Clouds*, c. 1915–26. Oil on canvas, 200 × 1275 (78¾ × 502). Musée de l'Orangerie, Paris. Photo RMN-Grand Palais (Musée de l'Orangerie)/ Michel Urtado

166 James Abbott McNeill Whistler, *Nocturne in Black and Gold, the Falling Rocket*, 1875. Oil on panel, 60.3 × 46.6 (23¾ × 18⅜). Detroit Institute of Arts. Gift of Dexter M. Ferry, Jr

167 James Abbott McNeill Whistler, *Nocturne: Blue and Silver – Chelsea*, 1871. Oil on wood, 50.2 × 60.8 (19⅞ × 24). Tate, London. Bequeathed by Miss Rachel and Miss Jean Alexander 1972. Photo 2019 Tate, London

Further reading

Marshall Becker, et. al., *30,000 Years of Art: The Story of Human Creativity Across Time and Space*, London, 2007

Bell, Julian, *Mirror of the World: A New History of Art*, London and New York, 2007

Berger, John, *Ways of Seeing*, London, 1972

Blunt, Anthony, *Artistic Theory in Italy 1450–1600*, Oxford, 1963

Borchert, Till-Holger, *Van Eyck to Dürer: The Influence of Early Netherlandish Painting on European Art*, London and New York, 2010

Bray, Xavier, et. al., *Goya: The Portraits*, exh. cat., National Gallery, London, 2015

——, *The Sacred Made Real: Spanish Painting and Sculpture 1600–1700*, exh. cat., National Gallery, London, 2009

Clark, Kenneth, *What is a Masterpiece?*, London and New York, 1992

Clark, T. J., *The Sight of Death*, London and New Haven, 2006

Cumming, Laura, *A Face to the World: On Self-Portraits*, London, 2010

Danchev, Alex, *Cézanne: A Life*, London, 2013

Dell, Christopher, *What Makes a Masterpiece?*, London and New York, 2010

Dormandy, Thomas, *Old Masters: Great Artists in Old Age*, New York, 2000

Eco, Umberto, *On Beauty: A History of a Western Idea*, London, 2010

Fried, Michael, *Another Light: Jacques-Louis David to Thomas Demand*, London and New Haven, 2014

Gombrich, E. H., *The Story of Art*, London, 2006

Hagen, Rose-Marie, *100 Masterpieces in Detail*, Cologne, 2015

Haskell, Francis, *History and its Images: Art and the Interpretation of the Past*, London and New Haven, 1993

Hay, Denys, *The Age of the Renaissance*, London and New York, 1967

Hirschauer, Gretchen A., et. al., *Piero Di Cosimo: The Poetry of Painting in Renaissance Florence*, exh. cat., National Gallery of Art, Washington, DC, 2015

Ilsink, Matthijs, *Hieronymus Bosch: Visions of Genius*, exh. cat., Noordbrabants Museum, 's-Hertogenbosch, 2016

Leymarie, Jean, *Dutch Painting*, Lausanne, 1956

Lopera, Jose Alvarez, *El Greco: Identity and Transformation*, Lausanne, 1999

Rideal, Liz, *How to Read Paintings: A Crash Course in Meaning and Method*, London, 2014

Rynck, Patrick de, *How to Read a Painting: Decoding, Understanding and Enjoying the Old Masters*, London and New York, 2004

Lynton, Norbert, et. al., *Looking into Paintings*, London, 1985

Schama, Simon, *Landscape and Memory*, London, 2004

——, *The Power of Art*, London, 2006

Uglow, Jenny, *William Hogarth: A Life and a World*, London, 2002

Vasari, Giorgio, *The Lives of the Artists*, Oxford, 1991

Ward, Ossian, *Ways of Looking: How to Experience Contemporary Art*, London, 2014

Westheider, Ortrud, and Michael Philipp, *Turner and the Elements*, exh. cat., Turner Contemporary, Margate, 2011

Wilson-Bareau, Juliet, *Goya: Drawings from his Private Albums*, exh. cat., Hayward Gallery, London, 2001

Wood, Michael, *Art of the Western World: From Ancient Greece to Post-Modernism*, New York, 1989

Zöllner, Frank, *Botticelli, Images of Love And Spring*, New York, 2007

Zöllner, Frank, and Johannes Nathan, *Leonardo da Vinci: The Complete Drawings and Paintings*, Cologne, 2015

Zöllner, Frank, et. al., *Michelangelo: Complete Works*, Cologne, 2007

Index

Look Again

To the memory of and with further apologies to John Berger, who we lost last year, this book is dedicated to my own compass in art and life, my dear dad John Ward, whose enthusiasm for my writings so often outweighs my own. The rest of my family were no less supportive, so again I owe my inspiration to them and specifically the trio of I, I & I. My thanks go to everyone at Thames & Hudson, not least my editor Roger Thorp.

Ossian Ward is Head of Content at the Lisson Gallery. He was previously chief art critic at *Time Out London*, and is the author of *Ways of Looking: How to Experience Contemporary Art* (2014).

On the cover: Peter Paul Rubens, *Tiger, Lion and Leopard Hunt*, 1615–17. Musée des Beaux Arts, Rennes. Photo 2019 Josse/Scala, Florence

Look Again: How to Experience the Old Masters
© 2019 Thames & Hudson Ltd, London
Text © 2019 Ossian Ward

Designed by Daly & Lyon

All Rights Reserved. No part of this publication may be reproduced or transmitted in any form or by any means, electronic or mechanical, including photocopy, recording or any other information storage and retrieval system, without prior permission in writing from the publisher.

First published in 2019 in the United States of America by Thames & Hudson Inc., 500 Fifth Avenue, New York, New York, 10110

www.thamesandhudsonusa.com

Library of Congress Control Number 2018945297

ISBN 978-0-500-23967-4

Printed and bound in China by C&C Offset Printing Co. Ltd